COMPLETE GUIDE TO

Bible Journaling

COMPLETE GUIDE TO

Bible Journaling

CREATIVE TECHNIQUES
TO EXPRESS YOUR FAITH

JOANNE FINK & REGINA YODER

DESIGN ORIGINALS
an Imprint of Fox Chapel Publishing
www.d-originals.com

Our deep gratitude to:

The manufacturers who provided products that we used to create some of the samples in this book: Caran d'Ache, Clearsnap, Crossway, Faber-Castell, Mrs. Grossman's, Sakura of America, Spellbinders, The Crafter's Workshop, and Tyndale.

The talented artists who shared their techniques and created art for the techniques section: Gail Beck, Dorian Eng, Leitha Hunt, Rebekah R Jones, Milagros Rivera, Korin Sutherland, and Samantha Trattner.

The incredible behind-the-scenes people whose support helped make this book possible: Leslie Davis, Connie Denninger, Deena Disraelly, Suzanne Dunn, Carl Fink, Philip Fleet, Gladys Gonzalez, Wilma Hostetler, Dana Kaplan, Penny Lisk, Jennifer Priest, Kristi Sorrell, Darla Stanfield, Dave Thompson, Jonathan Trattner, Angie Vangalis, Bobbi Ward, Amy Welday, David Welday, Ella Yoder, and Ernie Yoder.

The wonderful team at Fox Chapel: Peg Couch, Kati Erney, Kate Lanphier, Cindy Fahs, Alan Giagnocavo, Claudia Harrison, Llara Pazdan, Katie Weeber, Ray Wolf, and especially our amazing editors, Colleen Dorsey and Melissa Younger, for their numerous and invaluable contributions to the book.

The Bible journaling pioneers: Shanna Noel, who started it all, and the talented artists whose work graces the pages of this book.

Dedications

IN MEMORY OF MY MOTHER, JAN MILLER, WHO INSTILLED IN ME A DEEP LOVE FOR GOD'S WORD. HER FINGERPRINTS OF GRACE LINGER ON MY HEART.

—GINA

IN MEMORY OF MY FRIEND, BARBI DISRAELLY, WHO WALKED IN FAITH, REACHED OUT IN LOVE, AND MADE A PROFOUND DIFFERENCE IN THE WORLD. THE LIGHT OF HER SOUL CONTINUES TO INSPIRE ME.

—JOANNE

ISBN 978-1-4972-0272-6

Fox Chapel focuses on providing real value to our customers through the printing and book production process. We strive to select quality paper that is also eco-friendly. This book is printed on archival-quality, acid-free paper that can be expected to last for at least 200 years. It meets the minimum requirements of the American National Standard for Information Sciences—Permanence of Paper for Printed Library Materials, ANSI/NISO Z39.48-1992. This book is printed on paper produced from trees harvested from well-managed forests where measures are taken to protect wildlife, plants, and water quality.

© 2017 by Joanne Fink, Regina Yoder, and New Design Originals Corporation, *www.d-originals.com*, an imprint of Fox Chapel Publishing, 800-457-9112, 903 Square Street, Mount Joy, PA 17552.

We are always looking for talented authors. To submit an idea, please send a brief inquiry to acquisitions@foxchapelpublishing.com.

Printed in Singapore
Fifth printing

Library of Congress Cataloging-in-Publication Data

Names: Fink, Joanne, 1959- | Yoder, Regina.
Title: Complete guide to Bible journaling / Joanne Fink & Regina Yoder.
Description: East Petersburg : New Design Originals Corporation, [2017] | Includes index.
Identifiers: LCCN 2016054345 | ISBN 9781497202726 (pbk.)
Subjects: LCSH: Spiritual journals--Authorship. | Bible--Illustrations. | Art and religion. | Drawing--Themes, motives.
Classification: LCC BL628.5 .F56 2017 | DDC 248.4/6--dc23
LC record available at https://lccn.loc.gov/2016054345

WELCOME!

We feel incredibly blessed to be able to share our passion for Bible journaling with you through this book. Connecting with God's Word is important to each of us in different ways. Joanne, a calligrapher and artist, has been lettering scripture for more than three decades and considers it an integral part of her spiritual journey. She writes on walls and in sketchbooks and journals, but not in Bibles (except for making some examples for this book). Gina's interest in Bible journaling began when Joanne introduced her to the Bible journaling community in 2015. Something clicked, and Gina experienced a paradigm shift that made God's Word come alive to her in a new way. Gina's daily journaling in the margins of her Bible helps her discover God's truth and remember each particular encounter she has with God.

We hope that this book will inspire you to tap into your own innate creativity and use it in a way that brings you closer to God. May you be blessed, as we have been, to strengthen your faith as you connect with God's Word.

Joanne Fink & Regina Yoder

October 2016

WHAT YOU'LL FIND IN THIS BOOK:

Shanna Noel in her studio

Personal stories of the world's leading Bible journaling artists!

Techniques for lettering, drawing, and crafting with stencils, colored pencils, watercolors, acrylic paints, rubber stamps, washi tape, and more!

A **gorgeous gallery** of inspiring Bible journaling examples!

Bridgett Brainard

Tess Crawford

Hundreds of stickers, **vellum overlays**, and **traceable illustrations** printed on thin, Bible-compatible paper!

GIVE *Thanks* TO THE *Lord* FOR HE IS GOOD
PSALM 107:1

FAITH AMEN.

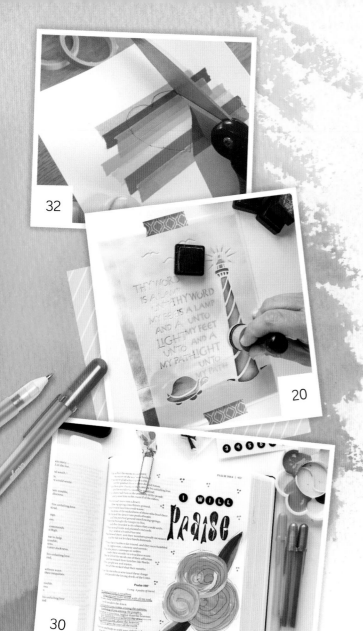

GETTING STARTED

TOOLS AND TECHNIQUES

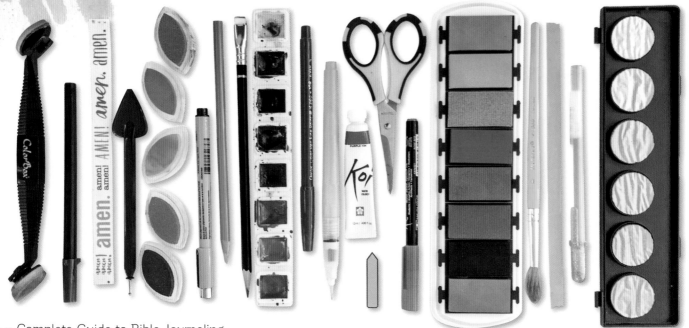

ARTIST PROFILES

GALLERY

124 | RESOURCES AND INDEX

BONUS SECTION

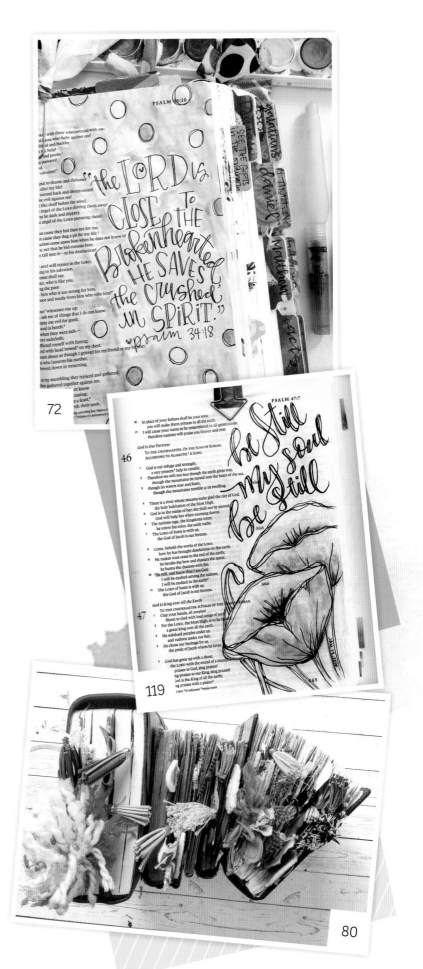

WHAT IS BIBLE JOURNALING?

Welcome to the wonderful world of Bible journaling! In its simplest definition, Bible journaling is a way to express your faith creatively. Putting pen to paper is a great way to remember and record biblical concepts that are meaningful and relevant to your life. Whether you are drawing, coloring, and writing right inside your Bible—the most commonly understood definition—or writing and illustrating scripture verses in a separate book or on paper alongside your Bible, the essential thing to understand is that Bible journaling is about creating while reflecting on God's Word.

This book consists of four sections that will fully introduce you to the joy of Bible journaling as well as to the growing community of people who find meaning by expressing their faith in this creative way. There is a how-to **techniques section**, chock-full of lettering, drawing, painting, and crafting techniques you can use to bring God's Word to life, as well as information on tools appropriate for Bible journaling. There is an **artist profile section**, where eleven of the world's leading Bible journaling artists share the stories of their personal faith journeys. There is a **gallery** full of inspiring examples of journaling God's Word both inside and outside the Bible. Lastly, there is a **bonus section** full of **instantly useable content**—including traceable designs, stickers, and Bible book tabs—to help you get started in Bible journaling right away!

As you explore the different sections of this book, take note of the variety of styles and techniques shown. Which ones appeal to you the most? It is always a good idea to test new tools and techniques—and even page layouts—before actually using them in your Bible. Many Bibles have an extra page or two at the back that you can use for this purpose.

It is also helpful to connect with others in the Bible journaling community. Several of the artists in the artist profile section have Facebook groups, and there are other groups you can join included in the resources section at the back of the book. For inspiration, video tutorials, and more, visit *www.biblejournalingjumpstart.com*.

These three interpretations of Proverbs 3:5 exemplify the three major styles of Bible journaling:

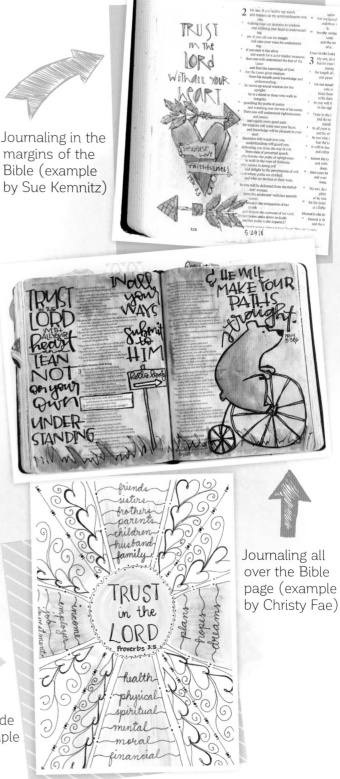

Journaling in the margins of the Bible (example by Sue Kemnitz)

Journaling all over the Bible page (example by Christy Fae)

Journaling outside the Bible (example by Hannah Ballesteros)

HOW TO BEGIN

Although this book discusses many different types of products, the focus of Bible journaling is not about the products—it's about the joy of creatively expressing the biblical truths you discover. Let the ART you create be an expression of your HEART for God.

As you read your Bible, allow God's Word to speak to your soul. It's worth taking time to quiet your heart and **be still** before beginning. Depending on where you are in your faith walk, you may be drawn to certain passages. Read the passage once to get an overview, and then again to dig deeper into the text. Look for a verse, phrase, or concept that speaks to you. Once you identify scripture that you find especially meaningful, try to determine what God is saying to you through that passage, so you can begin the process of bringing it to life by lettering, coloring, and/or illustrating its message. When you find a verse that resonates with you, ask yourself these questions:

- What does the scripture say?

- What does it mean?

- Which part is most important to me?

- Which words should I emphasize?

- How can I express the meaning visually?

Next, choose where you will write and/or illustrate your chosen verse. Many Bible journalers work in the margins of their Bibles; some boldly cover entire pages with art; and others prefer to journal in a sketchbook or on translucent sheets they attach to their Bibles. There isn't a right way or a wrong way to do it; it's your Bible, so you get to decide. Do whatever you feel comfortable doing. If you don't have a journaling Bible, or don't wish to write in your Bible, you can create your art on a separate piece of paper and insert it into whatever Bible you use. Many Bible journalers use a translucent stock, such as vellum tracing paper, so they can still see the Bible page through their art. It can be less intimidating to try new techniques and layouts on a separate piece of paper. If you like how the design turns out, you can redraw or even trace it into your Bible, or add it to your Bible as a tip-in (by taping it to the inside edge of a page) or as a tip-out (by taping it to the outside edge of the page).

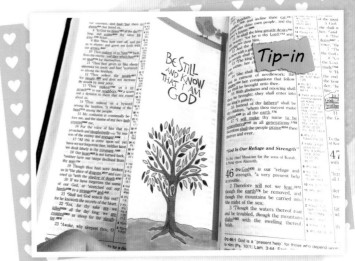

A tip-in is a piece of paper taped to the inside edge of a page.

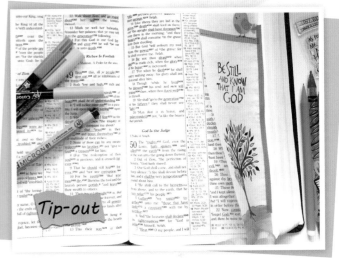

A tip-out is a piece of paper taped to the outside edge of the page.

The focus of Bible journaling is not the art but rather the significance of the message and what it means to you. Keep in mind that your design doesn't have to be perfect; it is simply a visual representation of the truth you discover in a particular passage. Don't be afraid to experiment with different tools and techniques until you discover ones that best allow you to connect with God's Word. Focus on developing your own style and using your journaling time as an act of worship. The time spent reflecting on God and His truth is invaluable—enjoy the journey!

Helpful Hint

When deciding how to attach your artwork to your Bible, keep in mind that a tip-in will affect how your Bible falls open, but a tip-out will not.

CHOOSING A BIBLE

With the growing interest in Bible journaling, more publishers are providing Bibles with added space for people to express their thoughts in a creative manner. It is helpful to understand the different options and features available so you can select a Bible that best meets your needs.

CHOOSING A TEXT VERSION

The Old Testament Bible text was originally written in Hebrew and Aramaic and later translated into Greek. Some Old Testament translations are based on the early Greek translation of the Hebrew/Aramaic text rather than the original text itself. The New Testament was originally written in Greek, the language largely used at the time. Today, Bible publishers offer three different types of translation: word-for-word, meaning-for-meaning, and paraphrased.

Word-for-word translations, such as the King James Version (KJV) and its modern counterpart the New King James Version (NKJV), most accurately follow the original text but can sometimes be difficult to understand because the English language has changed considerably in the 400 years since the KJV was published. The English Standard Version (ESV) is considered a word-for-word translation while at the same time taking into account differences of grammar and syntax between current literary English and the original languages.

Meaning-for-meaning translations, such as the New International Version (NIV) and the New Living Translation (NLT), typically use more up-to-date language and are easier to understand, but are sometimes considered interpretative translations of the text.

Paraphrased translations take a fair amount of liberty in interpreting biblical text and its meaning. They are easy to read but the level of accuracy is not as high as the other types of translations. The Message and The Living Bible are two of the most popular paraphrased Bibles.

Many people find it helpful to have more than one translation of the Bible so that they can compare and contrast the text for both accuracy and readability. Regardless of the Bible version you choose, the most important factor is that you actually use it! As you spend more time reading the Bible, you will find that God's Word becomes increasingly precious to you.

CHOOSING A LAYOUT

In addition to different translations, Bibles are also available in different sizes and formats. Most of the popular versions are available in both hardcover and softcover versions, in a variety of bindings, from elegant, embossed leather to colorful prints. Decide if you prefer a single-column or double-column layout. If you have trouble reading the small print, consider a large print edition. Some journaling Bibles have dark lines in the margins, while others have faint lines or no lines at all. There is even an interleaved Bible that has an entire blank page between each page of text. Keeping all these things in mind will help you select a journaling Bible that you will love to use.

Pictured from top to bottom: Standard double-column Bible, single-column coloring Bible, double-column interleaved Bible, single-column journaling Bible, double-column journaling Bible.

COLORING BIBLES

Several publishers have created coloring Bibles with illustrations already printed on some of the pages. There is also plenty of space for notes or art if you want to add your own. Pictured on this page are some examples of coloring Bibles so you can see the differences between them and decide for yourself if one of these is right for you.

On the left is the Holman Christian Standard *Illustrator's Notetaking Bible*. The designs are printed in light gray, making it easy to go over the lines with a pen or colored pencil. Most of the designs are abstract, like the one shown, as opposed to the combination of images and text featured in the other two Bibles. The center Bible is the New Living Translation *Inspire Bible*. The images in the margins are computer generated and somewhat more elegant than the hand-drawn artwork in the King James Version *My Creative Bible*, which is pictured on the right.

Keep in mind that you don't need a special journaling Bible to start creatively expressing your faith. This book includes methods of Bible journaling that will work in any Bible format, or you can use a notebook or sketchbook and journal outside the Bible. A wealth of wisdom and the joy of fellowship await you in the pages of God's Word. Grab a cup of coffee or tea and dig into its treasures.

DRAW
NEAR TO
God &
HE WILL DRAW
NEAR TO YOU

TOOLS AND

YOU'LL LEARN ABOUT...

You don't need to invest in expensive supplies to creatively express your faith, but for those who wish to experiment with different tools and techniques, this section will provide simple ways to use some of the most commonly available art supplies, such as colored pencils, watercolors, stamps, and stencils. It also includes basic layout techniques and a variety of lettering styles to try out. For a more in-depth look at the tools and techniques featured in this book, as well as where to find the supplies included in this section, visit **www.biblejournalingjumpstart.com**.

 While this section is designed to show you tools and techniques that allow you to express your faith in a visually attractive way, keep in mind that the art should not be the focus of your practice. You can make simple, meaningful doodled notes in the margins with a regular pen. That's all you really need to get started. Feel free to express your everyday faith in an everyday way. The key is to jump in and start right where you are with the materials you already have. Find joy in your ever-deepening relationship with God as you are intentional about spending time in His Word.

TRACING, DRAWING, AND PATTERNING

JOANNE FINK

TRACING

There are many ways to get art into your Bible even if you don't have a lot of drawing experience. One of the easiest methods is to simply trace an image. **The bonus section at the back of this book has a variety of designs that you can pull out and use for this purpose.** Find one you like, and then tape it to the reverse side of the Bible page with removable tape. Bibles are printed on thin, practically translucent paper, so you'll be able to see the design without much difficulty. Once the design is in place, trace it using a fine point permanent pen, like a Pigma Micron 005 or 01 pen, anchoring the page with your nondominant hand while you work. When finished, gently remove the tape and the traceable design from the back of the Bible page.

You can create your own traceable designs, too. Just draw an image on scrap paper or in your personal sketchbook or journal, working on it until you are satisfied with it, and then trace it into your Bible.

1. Tape the chosen design on the back of the page you want to trace it on (facedown).

2. Trace the design.

3. Remove the taped design to reveal your finished drawing. Color if desired.

DRAWING

You can also draw your own icons in your Bible to illustrate what the verse means to you. Practice by drawing the following step-by-step flowers and birds before creating your own unique variations.

DRAWING A SIMPLE FLOWER

1. **Draw the base.** Draw a circle with a spiral center, then add the flower petals, a stem, and leaves.

2. **Add lines.** Add accent strokes on the insides of the flower petals and on the outside edges of the leaves.

3. **Decorate.** Add more strokes inside the leaves and the petals. Add a second set of leaves at the base of the flower and close the stem with three circles.

4. **Thicken.** Add weight (line thickness) to the outside edge of the flower petals and leaves by thickening the lines.

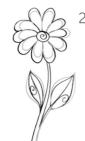

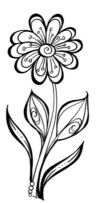

THE COMPLETED FLOWER!

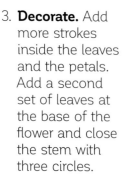

MORE SIMPLE IDEAS TO DRAW

1. Draw bird outlines.

2. Add wings and eyes.

3. Add legs.

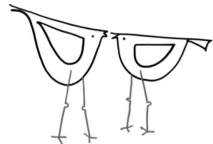

4. Add feathers.

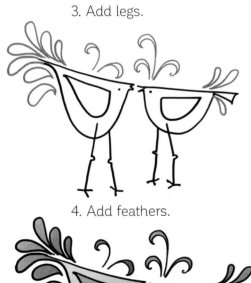

5. Add color.

1. Draw a cloud shape.

2. Add a second stroke.

3. Add patterning inside the spaces (see page 16).

4. Thicken the outer lines.

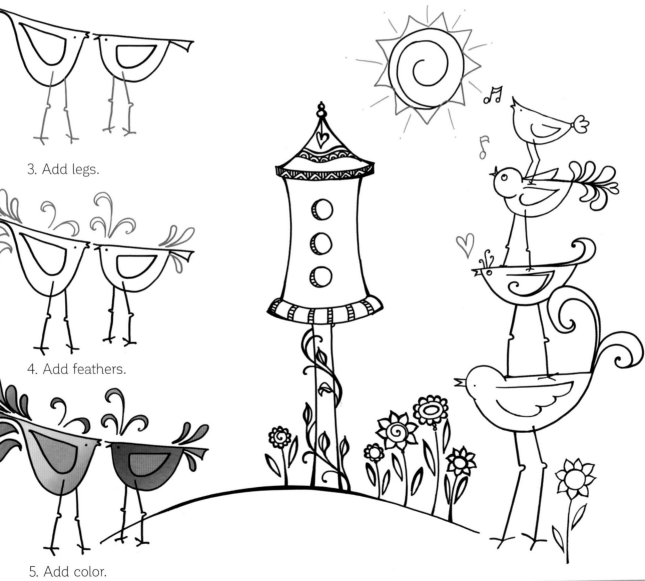

To practice, draw different types of birds, like the ones shown above right. Notice the different wing, beak, eye, and feather shapes. Mix and match features to create your own unique feathered friends!

DRAWING PATTERNS

Four Lines and a Circle Pattern

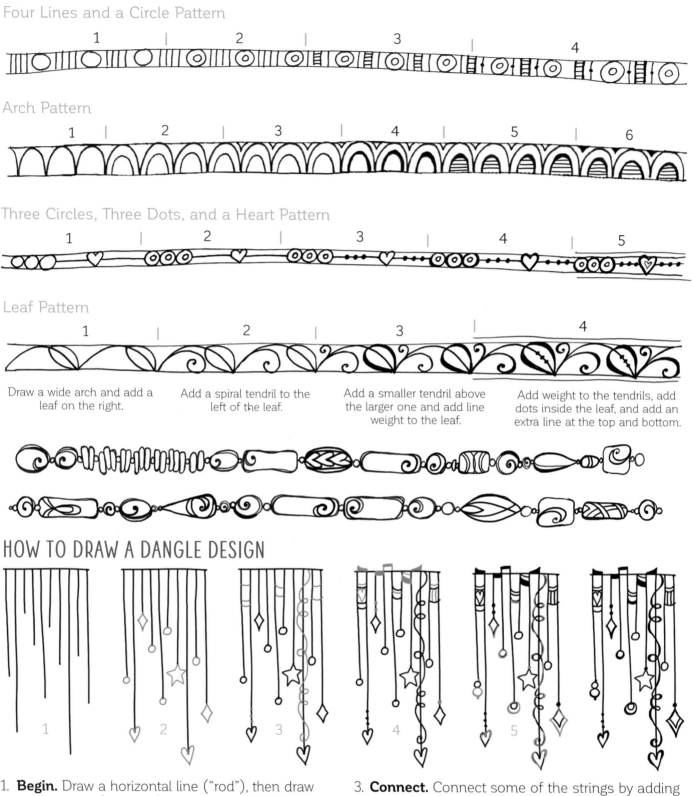

Arch Pattern

Three Circles, Three Dots, and a Heart Pattern

Leaf Pattern

Draw a wide arch and add a leaf on the right.

Add a spiral tendril to the left of the leaf.

Add a smaller tendril above the larger one and add line weight to the leaf.

Add weight to the tendrils, add dots inside the leaf, and add an extra line at the top and bottom.

HOW TO DRAW A DANGLE DESIGN

1. **Begin.** Draw a horizontal line ("rod"), then draw vertical lines ("strings") of different lengths.

2. **Add.** Add designs ("dangles") in your favorite shapes at the bottom of the strings.

3. **Connect.** Connect some of the strings by adding connecting lines ("cuffs"). Dots and swirls can add extra interest to the design.

4. **Decorate.** Add accent toppers to help solidify the design, then decorate the cuffs if desired.

5. **Thicken.** Add weight to the dangles and do any final touch-ups.

DRAWING A PATTERNED DANGLE HOUSE

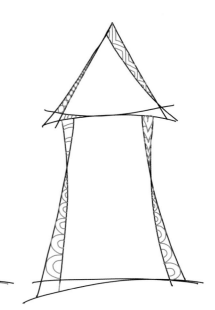

1. **Outline.** Draw a simple house outline; don't worry if the lines don't touch.

2. **Add.** Duplicate the strokes to add spaces around the perimeter.

3. **Decorate.** Extend the lines to close off the sections, then add patterns.

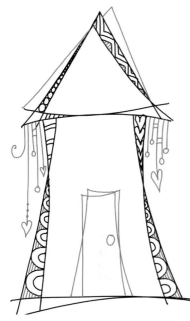

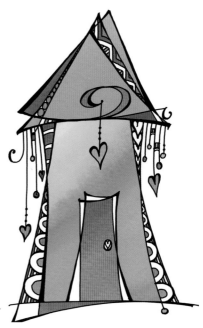

4. **Embellish.** Add a door and more patterns and dangles.

5. **Finish.** Add embellishments and finish the house by adding weight to the lines.

6. **Color.** Color as desired.

Try this elaborate dangle design along the top or side of a Bible page.

PAINTING BACKGROUNDS WITH STAMP PADS

JOANNE FINK

Stamp pads can be used to create translucent, colorful backgrounds, which are wonderful for Bible journaling as they don't obscure the text and you can write on top of them without clogging your pen. Additionally, if you are using a pigment inkpad, the ink won't bleed through, so there is no need to prep the page. (See page 28 for information about page prep.) This technique works best when you blend several shades of a color together with a dauber or sponge. To create a scene like the one in this example, you'll need two or more shades for each color group (sky, mountains, water, and trees). Always start with your lightest colors, and put the darker colors on top.

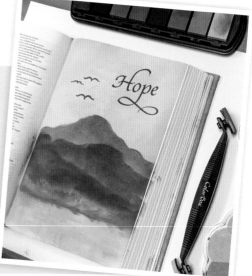

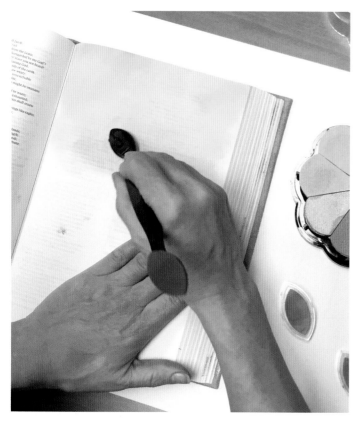

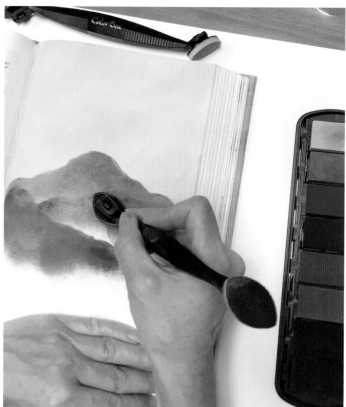

1. **Create the sky.** Press the applicator onto the lightest color inkpad and then, using a smooth, circular motion, apply the color to the page. Hold the page firmly with your nondominant hand. Repeat the process using similar shades of the pale color, overlapping one on top of the other. After you apply three or four different shades, put the original lightest color on your applicator and smooth any uneven areas.

2. **Create the mountains.** Switch to a darker palette, or create your own like the one shown here (made with Colorbox inkpads). Starting with the lightest shades of the darker palette, paint the first mountain. Then, using the medium shades, paint a second mountain. Finally, create a third mountain closest to you by using the darkest shades.

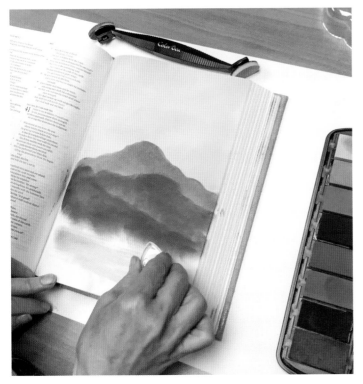

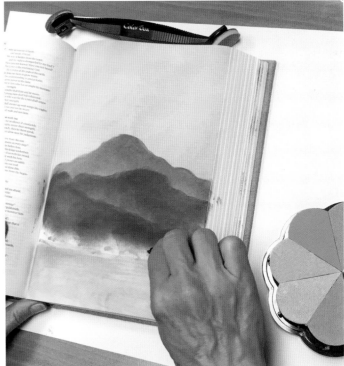

3. **Create the water.** Starting a little below the mountain line, apply shades of pale blue in straight, horizontal strokes. Blend the blue colors together with your applicator.

4. **Create the trees.** Dab light green ink directly onto the paper between the water and mountain line. Then dab dark green ink on top. They will look more like distinct trees if you don't blend them together.

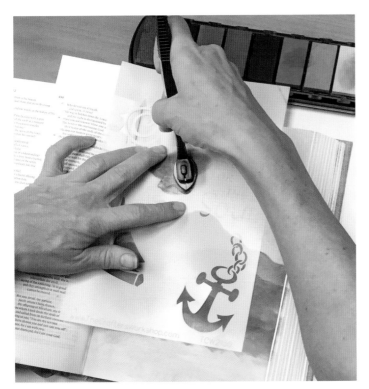

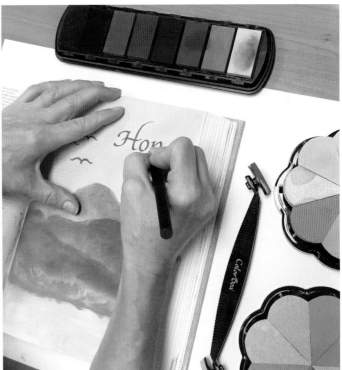

5. **Add the birds.** If you're using a bird stencil, position it where you want the birds and use the applicator to gently dab the ink until the area is covered. If you don't have a stencil, you can simply draw the birds once the ink is dry.

6. **Add the lettering.** The word "Hope" in this example was lettered in italic calligraphy with Sakura's 3mm Pigma Calligrapher pen, but you can add text with a rubber stamp, stencil, or sticker, or hand-letter it in your favorite style.

STENCILS

JOANNE FINK & REGINA YODER

As shown on the previous page, you can create beautiful artwork by dabbing stencils with different kinds of ink. The versatility of stencils makes them a great option for Bible journaling. If a stencil is too large to fit in the available space, you can often use part of the image and still get a great result. You can also mix and match designs from different stencils to illustrate a particular concept.

Applying a stencil is as simple as holding or taping the stencil in place as you dab with ink.

Helpful Hint!

After use, wipe off both sides of your stencil with a damp paper towel to ensure you don't unintentionally smear ink onto your next stencil project.

These sun and tree images were created by applying Ranger Tim Holtz Distress ink with an applicator through one of Joanne's Inspired Journaling stencil designs for The Crafter's Workshop. Distress inks are dye based and blend well, but tend to bleed through the paper, so use light pressure to apply or prep the page.

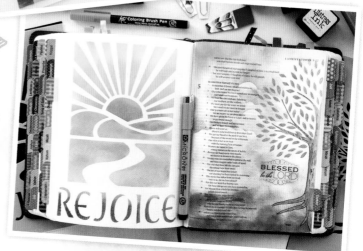

SIMPLE FEATHER STENCIL TECHNIQUE

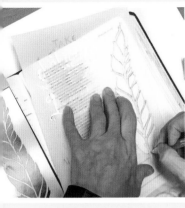
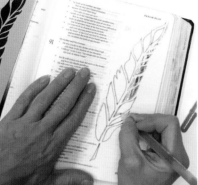
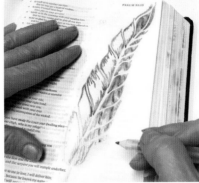
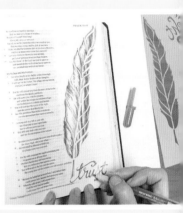

1. **Trace.** Place the stencil where you want the design and trace only around the edges.

2. **Fill.** Using the same pen, completely fill the right half of the outlined areas.

3. **Partially fill.** Partially fill in the other half of the areas with the same color, using short strokes to create the illusion of dimension.

4. **Write.** Write the word or words you want to focus on. Embellish and enhance the line weight if desired.

STENCIL INSPIRATION

All the images on pages 20–21 were created with stencils from Joanne's Inspired Journaling line from The Crafter's Workshop.

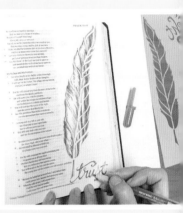

This striking design by Samantha Trattner was drawn with metallic Gelly Roll gel pens on a page prepped with The Crafter's Workshop black gesso.

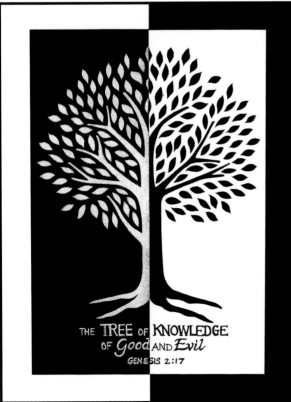

Gail Beck made this stunning silhouette tree with black and white acrylic paints and a stenciling brush. She used black and white gel pens (Gelly Roll by Sakura) for the lettering.

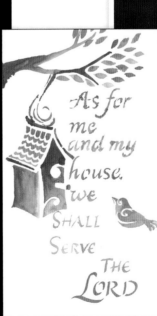

This charming design by Milagros Rivera was created with Ken Oliver Color Burst watercolor powder and three different Inspired Journaling stencils.

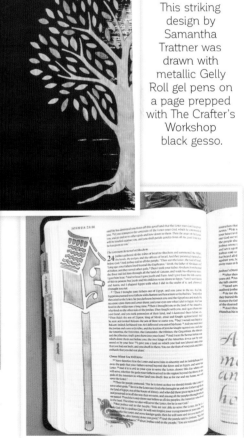

Regina Yoder used the same Inspired Journaling birdhouse stencil and Ranger Distress inks to create this design.

COLORED PENCILS

LEITHA HUNT

Colored pencils are a safe and popular medium to use in your Bible. They are relatively light in color compared to markers and paints, and they don't bleed through the paper. As seen in the samples here, you can get nice results from any brand of wax- or oil-based pencil. Compare some of the popular brands of colored pencils, and then follow along for instruction on creating a beautiful gradient with colored pencils.

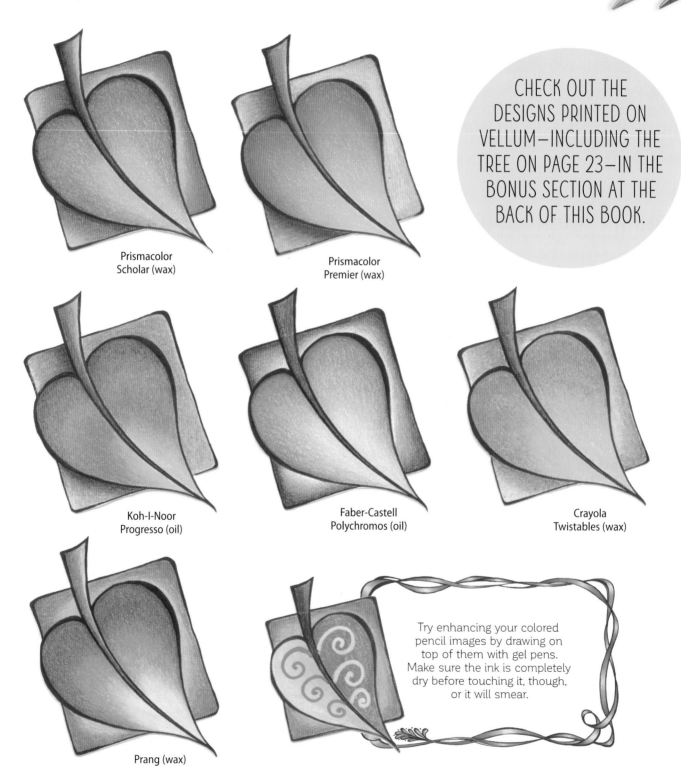

Prismacolor
Scholar (wax)

Prismacolor
Premier (wax)

CHECK OUT THE DESIGNS PRINTED ON VELLUM—INCLUDING THE TREE ON PAGE 23—IN THE BONUS SECTION AT THE BACK OF THIS BOOK.

Koh-I-Noor
Progresso (oil)

Faber-Castell
Polychromos (oil)

Crayola
Twistables (wax)

Prang (wax)

Try enhancing your colored pencil images by drawing on top of them with gel pens. Make sure the ink is completely dry before touching it, though, or it will smear.

BLENDING A BEAUTIFUL GRADIENT

With a bit of patience, it is possible to create a seamless gradient blend with any shades.

1. **Apply one color.** Starting at one end of the leaf, using very light pressure, apply the palest shade to the bottom quarter of the leaf.

2. **Apply more colors.** Switch to the next palest shade and, still using very light pressure, apply the second shade by partially overlapping the first color, then continue upward until more than half of the leaf is colored. Do the same with the next two shades, and apply the darkest color to the top of the leaf, only on the outer edge.

3. **Deepen the colors.** Continue adding color in this manner until the colors are dark and vibrant. Then, using heavier pressure, apply a final layer with all colors.

4. **Burnish.** To make sure the white of the paper does not show through the design, blend the colors together using heavy pressure by going back over the drawing with a burnishing pencil (a wax pencil without any color) or with the lightest shade used in the design.

FUN IDEAS AND EFFECTS

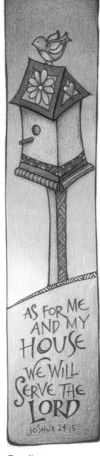

Gradients are an effective way to color a sky scene, such as the one behind this birdhouse.

You can use one color to make a lovely shading effect. Simply vary the pressure to go darker where you want a darker shade and lighter where you want it lighter.

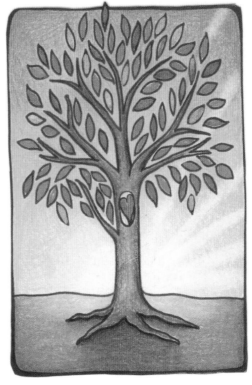

Since the light is behind the tree, use darker greens for the grass in front of it to create a shadow. Create a starburst effect by simply erasing the colored pencil using a clean white eraser (pink erasers are not recommended, as they can stain the paper). Then use a soft-bristled paintbrush to brush away the eraser crumbs.

WATERCOLORS

JOANNE FINK

If you want to add a touch of painterly elegance to your piece, consider using watercolors. The more water you add, the paler your color will be. While watercolors work best on watercolor paper, you can get great results with them in your Bible. Try all the different types of watercolors described in this section—watercolor pencils, brush markers, pans, and tubes—to find the tool that works best for you. Watercolor pencils are a great choice for beginners, because you can use them as a pencil, or add water to get a deeper, more blended image.

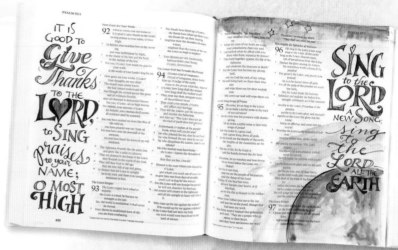

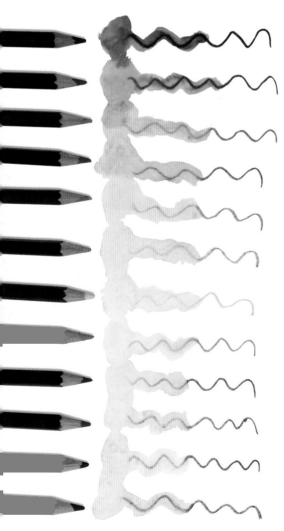

These pieces were colored by Leitha Hunt with watercolor pencils and then the top half of the design was blended with water.

WATERCOLOR PENCILS

Watercolor pencils are unique because they can be used as a colored pencil or, simply by adding water, as watercolors. You can even pull color directly from the pencil point with a wet brush for very intense color.

1. **Color.** Apply color to your desired area as if you're using a normal colored pencil.

2. **Add water.** Using a paintbrush or water brush, add water to dissolve and blend the color on the page.

3. **Dry.** Allow the area to dry completely before adding embellishments or text.

Water brush

WATERCOLOR BRUSH MARKERS

Watercolor brush markers are versatile, dye-based, water-soluble markers that can be used to letter, color, and paint. Be sure to use markers like Sakura's Koi® Coloring Brushes, as we did here, which blend beautifully when touched with water. This type of painting works best on watercolor paper and should **not** be used directly on Bible pages unless they are prepped first.

CREATING A BACKGROUND WASH

These markers work great to create a colorful background that you can write on without damaging your writing tool.

These markers bleed significantly if you don't prep the page first. The bottom half of the page shown here had clear gesso applied prior to adding the marker, while the top did not (see more info on page prep on page 28). Note how the color bled through the page and onto the next page.

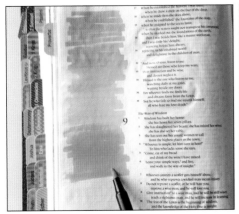

1. **Add color.** Select a few colors that will blend well together. Using short strokes, lightly brush ink onto the area where you want your background wash.

2. **Add water.** Working downward from the top of the page, add water with a water brush or paintbrush and move the ink from left to right and then down, blending each color into the next.

3. **Allow to dry.** After the ink is completely dry, you can add hand-lettered text, stickers, stamps, or other embellishments.

BEAUTIFULLY BLENDING A DESIGN

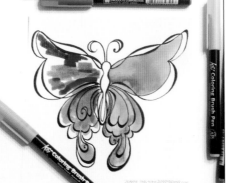

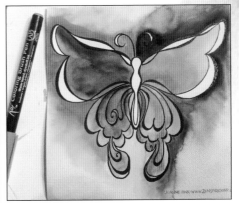

1. **Add color.** Roughly color in the spaces you want to color. There's no need to fill the spaces completely. This technique works best if you apply the colors in rainbow order.

2. **Blend.** Starting with the palest color, use a water brush to blend the marker strokes together. It will be easy to fill in the spaces. Continue with a new area, additional rough coloring, and more blending.

3. **Color the background.** Add color roughly to the background, then, starting with one of the seams between colors, blend with the water brush. Work clockwise until you are done.

TUBE WATERCOLORS

In addition to watercolor pencils and markers, you can use tube or pan watercolors to create painterly effects on your Bible pages. First, let's go over the technique for tube watercolors. We'll use tube watercolors to paint a background wash using a flat brush.

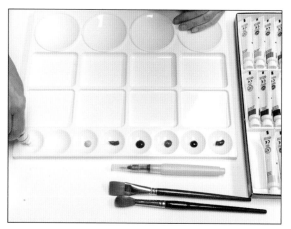

1. **Add paint.** Put a small amount of each color of paint into your palette.

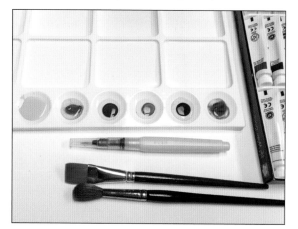

2. **Add water.** Add water to each paint color, referring to the photo to get an idea of how much water to add. Then stir each color to create a thin consistency.

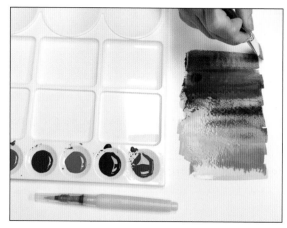

3. **Test.** Test the colors on scrap paper to make sure they are the shade you want.

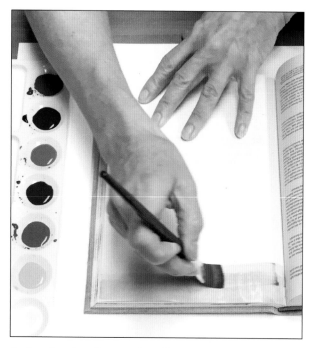

4. **Apply the first color.** Starting at the top of your page, start applying color in a thin layer.

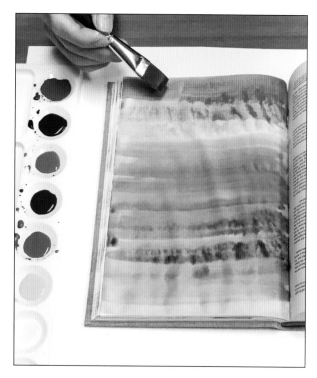

5. **Add more colors.** Continue to cover the page as desired. Make sure you let the page dry completely before closing the Bible or adding text or embellishments.

PAN WATERCOLORS

Now, let's go over the technique for pan watercolors. We'll use a small pointed brush like a Winsor & Newton series 7 #1 and pan watercolors to color in details of a design that has been drawn with a permanent pen. Make sure whatever design you are coloring was drawn with a permanent pen—not a water-based ink— because non-permanent ink may run when it gets wet.

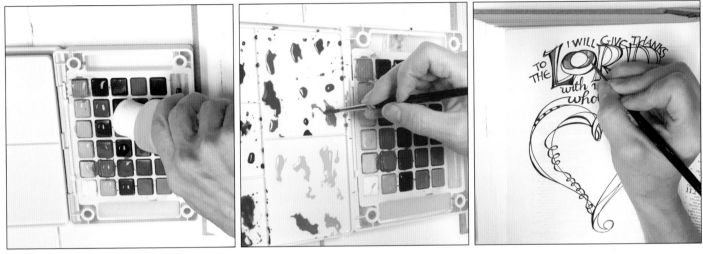

1. **Add water.** Add a bead of water to the top of each color in your watercolor pan. Allow it to soak for a few minutes until it is slightly dissolved.

2. **Move the color.** Put a small amount of each color onto the empty part of the palette to work with rather than working directly from the pan colors.

3. **Start painting.** Starting at the top of the page, color each section of your design. Look at the photo to see how the brush should be held. Rinse your brush in a container of clean water when changing colors.

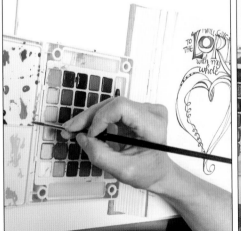

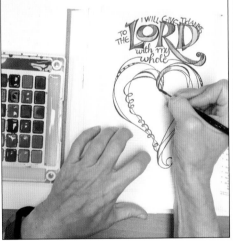

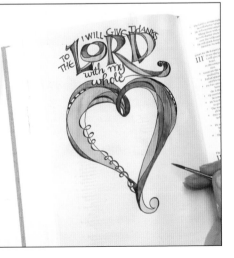

4. **Remove excess paint.** As you work, after dipping your brush in the paint, remove excess paint by pulling your brush against the side of the palette. This will control the amount of paint and help keep the paint from running on the page.

5. **Add more color.** Continue adding color left to right (if you're right-handed!), working your way down the page.

6. **Allow to dry.** Allow the page to dry completely before closing the Bible or adding more embellishments.

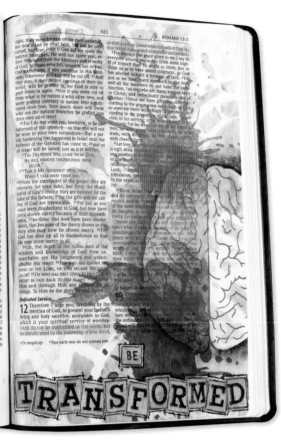

PAGE PREP: PREVENTING BLEED-THROUGH

REBEKAH R JONES

Watercolors, or any wet media, can wrinkle or tear thin Bible paper, and markers can bleed through the paper. If you plan to use wet media, consider prepping the pages with clear gesso to protect thin Bible paper and keep it from wrinkling. Page prep takes a little time, but makes creating in your Bible less stressful. It will essentially look like there is nothing extra there, and nothing will be able to bleed through, weaken, or wrinkle your Bible page. You won't have to be distracted by how your supplies will act on the paper; you will be able to simply focus on letting the Word of God transform your life. Rebekah R Jones, whose profile is on page 92, has graciously shared her simple six-step page prep technique. For detailed information on brands of supplies and extra tips for best results, visit her website, *www.rebekahrjones.com*.

MATERIALS

- **Journaling Bible:** Regardless of which Bible you choose, most Bibles have thin paper that may need page prep.

- **Blending Tool/Foam Applicator:** Use this to apply gesso to the page.

- **Heat Tool:** A craft heat tool will quickly dry your prepped page with a smooth finish. Air drying results in a wrinkly page; a normal hair dryer is too cool to dry a Bible page quickly enough to avoid wrinkling; and other embossing heat craft tools are often too hot and could scorch your Bible paper.

- **Clear Gesso:** For delicate, thin Bible pages, you want a clear gesso that is super smooth and has a matte finish, so that it doesn't hurt your Bible, make the text unreadable, or cause the pages to stick together.

- **Nonstick Craft Sheet:** Reusable, nonstick, and heat-proof craft sheets protect around and under your Bible page as you page prep and create. Cut craft sheets to size, a little larger than your Bible pages, for repeated use.

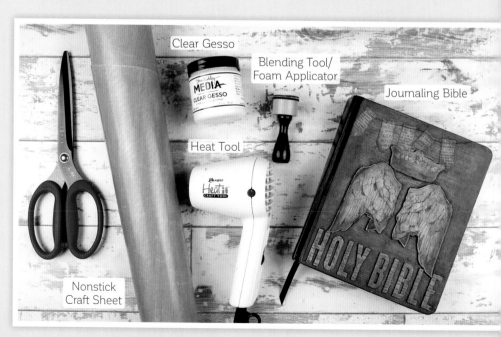

Clear Gesso

Blending Tool/ Foam Applicator

Journaling Bible

Heat Tool

Nonstick Craft Sheet

LET'S PREP A PAGE!

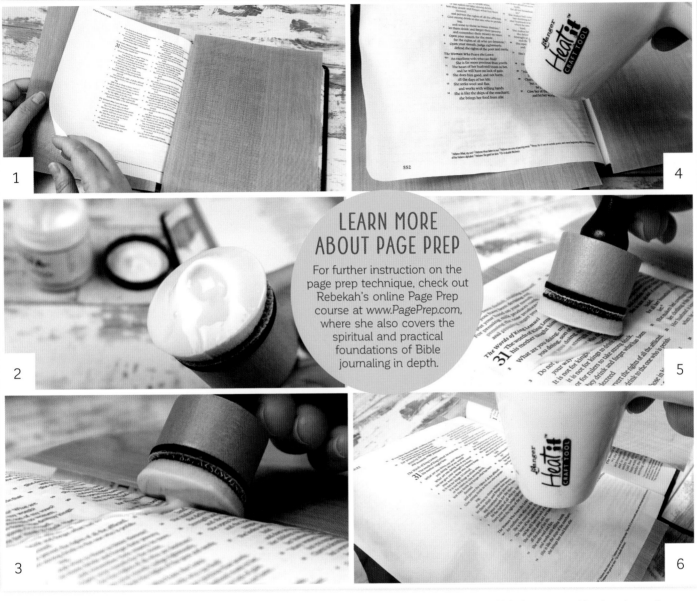

LEARN MORE ABOUT PAGE PREP

For further instruction on the page prep technique, check out Rebekah's online Page Prep course at www.PagePrep.com, where she also covers the spiritual and practical foundations of Bible journaling in depth.

1. **Position the craft sheets.** Lay one customized craft sheet under the Bible page you want to page prep and place the second sheet over the adjacent page to protect it.

2. **Load the blending tool with gesso.** Shake the gesso bottle and pour some gesso into the bottle's lid. Load a blending tool with gesso by dipping it into the lid. If you're using a tube, simply squeeze gesso directly onto your tool.

3. **Apply the first layer of gesso.** Starting from the binding and working outward in long strokes, glide the loaded blending tool across the entire page. Reload your tool about two to four times in order to get a sufficient first layer of gesso.

4. **Heat dry the page.** Working quickly, begin to heat the page, always pointing the heat tool safely away from your hand. Avoid touching the wet surface so as not to disturb the layer you're heat setting. As the page dries, gently pull the page taut to ensure it dries with a smooth finish.

5. **Apply a second layer of gesso.** Once your first layer of gesso is dry, apply a second layer to further strengthen your page and to ensure all areas are covered.

6. **Finish the second layer.** Heat dry the page again, gently pulling the page taut for a smooth finish. Once it's dry, you're ready to create!

Tip: Wait until a prepped page has cured overnight before using felt-tipped pens and markers. This will prevent any unnoticed damp gesso from soaking into pen tips and ruining them.

ACRYLIC PAINT

REGINA YODER

Acrylics are an opaque, water-based paint that dries quickly and can be watered down for a more translucent look. Acrylic paints come in both bottles and tubes and are available in a wide array of colors.

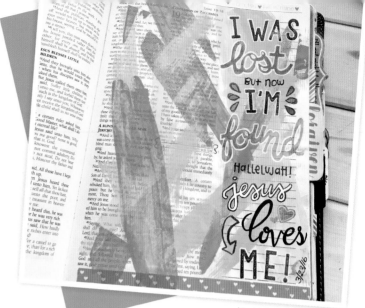

Korin Sutherland

PAINTING EASY STRIPES

You can make stripes quickly and easily using this simple method!

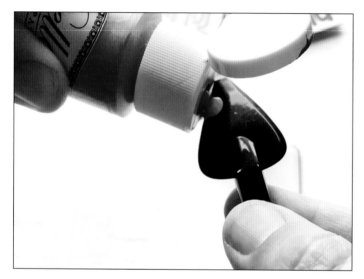

1. **Add paint.** Add a tiny blob of paint to a sticker placer tool or the very end of a used gift card. A sticker placer will give you skinny color layers, and a card will give you wider color layers.

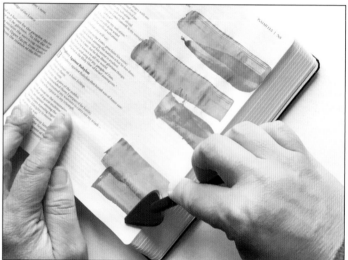

2. **Wipe.** Hold the tool at a 45-degree angle and drag a thin layer of paint across the Bible page. Repeat with the colors of your choice.

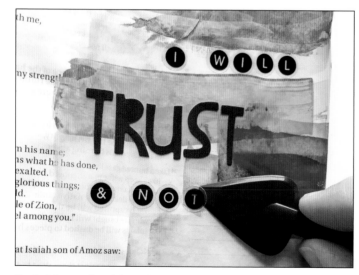

3. **Add words.** After the paint has dried, add alphabet stickers or letter your desired text by hand.

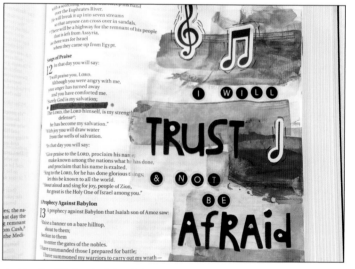

4. **Embellish.** Add additional embellishments if desired.

PAINTING ACCENT FLOWERS

You can avoid painting directly in your Bible, if you'd like, by painting an accent on a separate piece of paper and then gluing it in place on the Bible page.

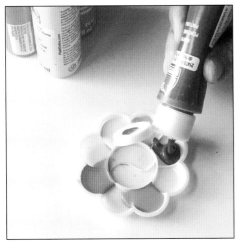

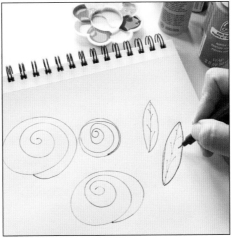

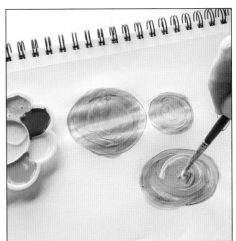

1. **Prepare the colors.** Choose three coordinating flower colors (such as pink, orange, and yellow), plus two leaf colors. Put a little of each color in a separate well of your palette. Add water for a thinner consistency if desired.

2. **Draw the pieces.** Using a black permanent pen, draw several sizes of round swirl flowers and long, narrow, veiny leaf shapes on a separate piece of paper or thin cardstock.

3. **Color the flower centers.** Using circular strokes, apply the darkest flower color to your flower shape. Immediately apply the middle color so they blend a little bit. Finally, apply accent strokes of the lightest color on top.

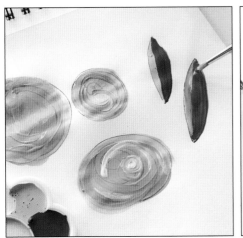

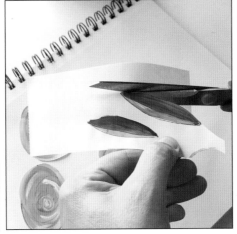

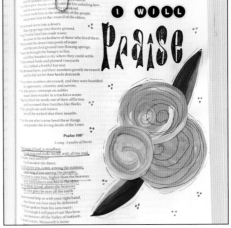

4. **Color the leaves.** Using a long, straight stroke, paint half of a leaf with dark green. Then paint the other half with light green and blend in the middle.

5. **Cut out the pieces.** Once the paint is completely dry, cut out all the flowers and leaves. If you'd like the drawn lines to show through more obviously, add them on top with a gel pen or ballpoint pen. (Do not use a Pigma Micron pen, or other technical pens, as the acrylic paint can damage them.)

6. **Attach the flowers.** Using a glue stick or double-sided tape, affix the flowers and leaves onto your page. Add wispy black lines around the flowers and leaves, plus additional embellishments and text if desired.

WASHI TAPE

REGINA YODER

Washi tape, which comes in rolls of different widths, colors, and patterns, is made from rice paper and is widely used by Bible journalers in a myriad of creative ways because it is repositionable and easy to write on. Some other tape products are made of different materials and feature waxy, shiny, and/or glittery surfaces. If you plan to write on these, it's best to use a permanent marker. You'll find many inspiring samples featuring washi tape in the artist profile and gallery sections of this book. Here are some quick and easy things you can create with washi tape.

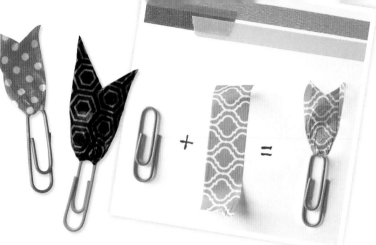

MAKING A PAGE MARKER

Stick a short piece of tape through one end of a paper clip and fold it in half onto itself. Trim the end in a V shape as shown. These mini bookmarks can be used to mark your favorite passages or journal entries.

MAKING COLORFUL CUT-OUTS

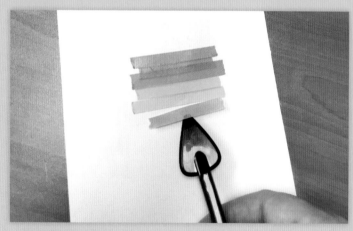

1. **Stick.** Adhere strips of washi tape to a piece of paper.

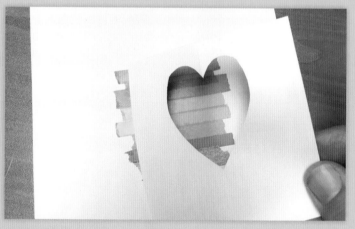

2. **Draw.** Draw the shape you want to cut directly on the washi tape. If you don't want to draw it freehand, you can use a simple stencil.

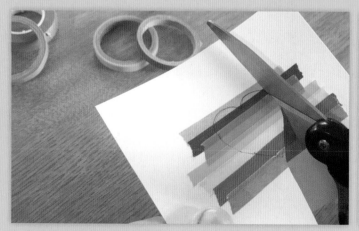

3. **Cut.** Cut out the shape and add an illustration or lettering if desired.

4. **Attach.** Adhere the shape to your Bible page.

ADDING ACCENTS

Washi tape can add a vibrant pop of color to your pages and give you clean lines to write text on. Plan your text layout and apply the tape to the area where you want your text or image to be. You can make the area as big or as small as you'd like. It can be a small accent or a larger background of color. Once you've made the base, add hand lettering, stickers, or die cuts to document the verse that is especially meaningful to you.

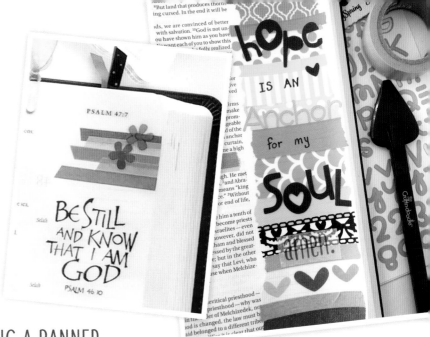

CREATING A BANNER

Fold small rectangles of washi tape over a piece of string or floss and trim each piece in a triangular shape for a fun accent.

VISIT
www.biblejournaling
jumpstart.com
FOR VIDEO TUTORIALS ON WASHI TAPE AND OTHER TECHNIQUES

MAKING WASHI DANGLES

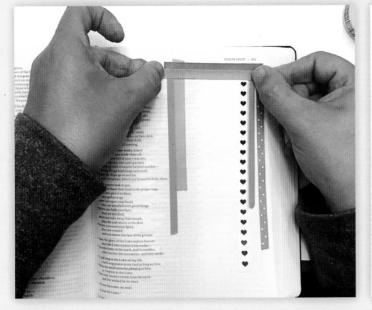

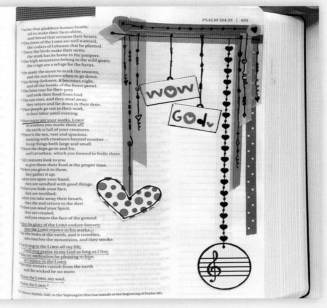

1. **Stick.** Apply strips of washi tape vertically in various lengths and colors. Then apply more strips horizontally at the top, covering the top ends of the vertical pieces.

2. **Decorate.** Add dangle designs (see page 16 for instructions) with a pen, then add any additional desired embellishments, such as stickers.

STICKERS AND DIE CUTS

REGINA YODER

CHECK OUT THE READY-TO-USE STICKERS IN THE BONUS SECTION AT THE BACK OF THIS BOOK!

There is a wide array of stickers with different features available on the market. Some are good for writing on, some have words that you can add to your page instantly, and others are letters that you can use to spell out any word you want. Stickers also come printed on either a clear or an opaque background. Both are useful for different things; you just need to consider if you want your Bible page background to show through or not. Sometimes, if you've created a colorful background, then a clear sticker on top might be hard to see because the background shows through and interferes with the clarity of the sticker design. If you are adding a clear sticker on top of a white area, though, it will stand out beautifully.

ALPHABET STICKERS

Alphabet stickers are an effective way to create a customized message on your Bible page. Plan your design to ensure that what you want to express will fit in the available space. (A sticker placer tool or pair of tweezers is helpful for placing small stickers.) Before placing the stickers, think about how they will look with the other elements you plan to add to the page. You can emphasize certain words and create a contemporary layout by using different styles and sizes of alphabet stickers.

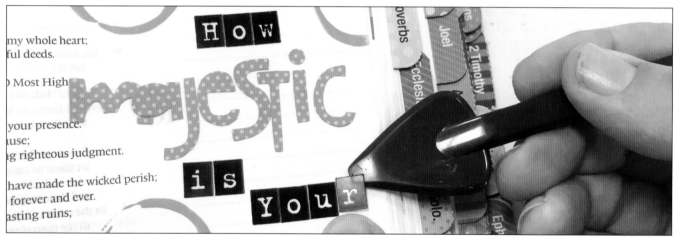

WORD STICKERS

Word stickers are great because the letters flow together in a way you can't easily achieve with individual alphabet stickers. They also work well when you want to make a quick note or reminder of what a passage is about, but don't want to take a lot of time to do a more complicated design yourself.

1. **Place.** Color the background if desired, then place the word sticker where you'd like it, smoothing it down to remove air bubbles and wrinkles.

2. **Underline.** Underline the verse you'd like to remember to accompany the sticker.

BACKGROUND/ BORDER STICKERS

Want to decorate your Bible page quickly? Try one of the **full-adhesive background stickers in the bonus section** of the book. You can write a prayer, sermon notes, or your favorite verse and adhere it to your Bible. Plus, here's a hint: if you've had something bleed through from the previous page, a full-adhesive background sticker will cover it up!

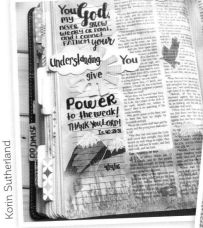

Bonus! Visit www.biblejournaling jumpstart.com for free downloadable margin printables.

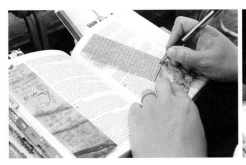

1. **Write.** Add sermon notes, a favorite verse, or a prayer to your background sticker.

2. **Attach.** Peel off the adhesive backing and attach, or adhere it to your Bible page with washi tape as a tip-in.

3. **Smooth.** Place the sticker in the margin, starting at the top and smoothing it as you move down the page.

DIE CUTS

Die cuts, or precut shapes, are another easy way to illustrate the concepts you want to remember. After preparing the background, lay out your text and choose the placement for the die cuts you'd like to add. You can even place die cuts on the edge of the page so that they double as tabs. When it's time to adhere the die cuts, you can use a glue stick, double-sided tape, washi tape, or glue dots.

Korin Sutherland

These die cuts double as tabs that make the page easy to find.

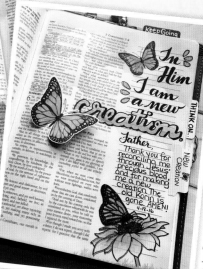

Korin Sutherland

Try a three-dimensional look like this with your die cuts.

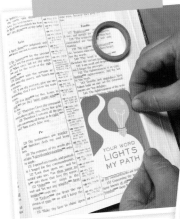

You can insert a die cut with journaling on the back of it.

Die cuts are especially useful in non-journaling Bibles because you can use the space on the back of them to journal. Tape the die cut in your Bible with washi tape so the text underneath can be viewed.

RUBBER STAMPS

DORIAN ENG

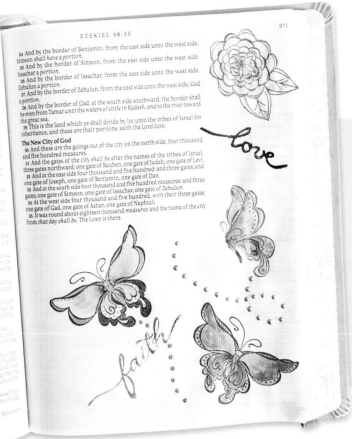

Rubber stamps fall into two basic categories: rubber stamps mounted on wood and clear stamps that cling to acrylic blocks. For Bible journaling, clear stamps are preferred for ease of placement. Stamp pads vary in ink types: pigment, chalk-like, dye, and permanent. Both pigment and chalk-like pads have minimal bleed-through, and chalk-like inks dry quickly. We highly recommend prepping the page (see page 28) if you want to use dye or permanent inks in order to ensure that the ink does not bleed through to the next page. Whatever inkpad you choose, test all products and techniques on scrap paper to make sure you can get the results you want. Follow these easy steps to add beautiful images to your Bible or journal.

BASIC STAMPING

1. **Ink**. Press the stamp onto the inkpad, ensuring full coverage of the image.

2. **Press.** Promptly press the stamp on the desired area with firm, downward pressure, taking care not to move or rock the stamp. Then lift the stamp straight up off the page. If the Bible's cover does not provide a firm, flat base under the page, it may be necessary to slip a stiff piece of paper underneath the page being stamped.

Helpful Hint!

The longer you press the stamp down on the page, the darker it will appear (as you can see in the image to the right). If you are new to stamping, it's a good idea to practice on a separate piece of paper before stamping in your Bible.

HAND-COLORED STAMPING

Use this technique to create a custom, multicolor effect.

1. **Add color.** Apply color to the stamp with watercolor brush markers. When you're happy with the colors, reactivate the ink just before stamping by exhaling on the stamp, similar to breathing on a windowpane. You could also spray the stamp with a very fine mist of water to reactivate the ink.

2. **Press.** Press the stamp down firmly in the desired location, then lift straight up to reveal the transferred image.

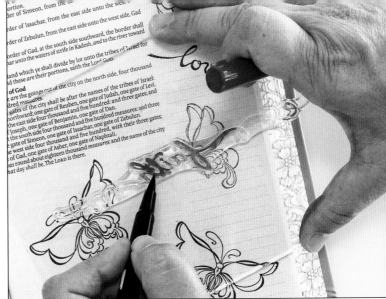

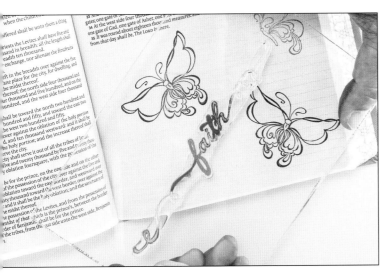

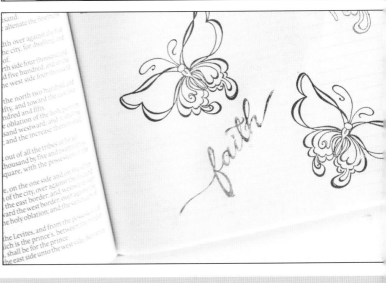

RUBBER STAMP IDEAS

COLORED PENCILS

Layer the pencil colors with light pressure. Use a white colored pencil to blend the entire colored area. See more info on colored pencils on page 22. (Products used: VersaMark stamp pad, Prismacolor pencils)

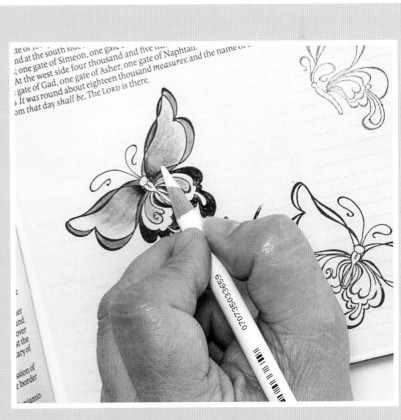

Helpful Hint!

Clean stamps after use by gently tapping the stamps on a damp paper towel in order to keep them soft and pliable.

RUBBER STAMPS (CONTINUED)

WATERCOLOR PENCILS

Watercolor pencils plus a water brush make for a very nicely blended second butterfly. See more info on using watercolor pencils on page 24. (Products used: VersaMark stamp pad, Derwent Inktense watercolor pencils, Sakura water brush)

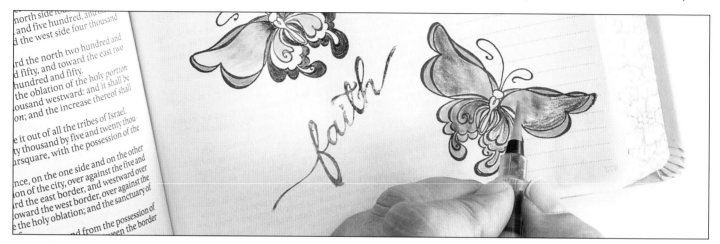

WATERCOLORS

Use a light touch and very diluted paint to watercolor a third butterfly. See more info on pan watercolors on page 27. (Products used: ColorBox Chalk stamp pad, Sakura Koi watercolor portable sketch kit, Sakura water brush)

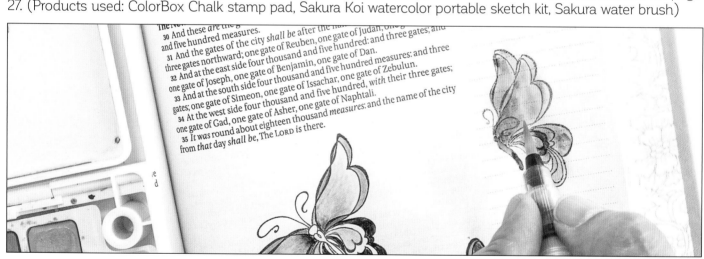

WATERCOLOR MARKERS

This flower was lightly colored with a watercolor marker. The marker ink was applied indirectly—the ink was placed on a plastic palette first, and then picked up with a water brush to be applied to the page. See more info on watercolor markers on page 25. (Products used: ColorBox Chalk stamp pad, Sakura water brush, Tombow brush marker)

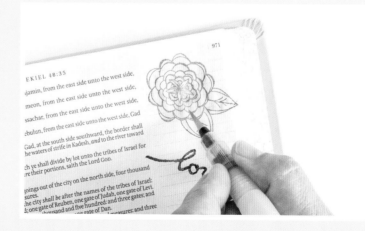

FOIL

First, stamp a word. Once the ink is dry, trace over the letters with a glue pen (not a glue stick—a specialty glue pen made for this purpose). Once the glue has dried to a tacky consistency (after a few minutes), lay metallic foil over the image and burnish it with something firm but not abrasive. Then peel off the extra foil to reveal the foil word! (Products used: Therm O Web Deco Foil transfer sheet, VersaMark Pigment stamp pad, Sakura Quickie Glue pen)

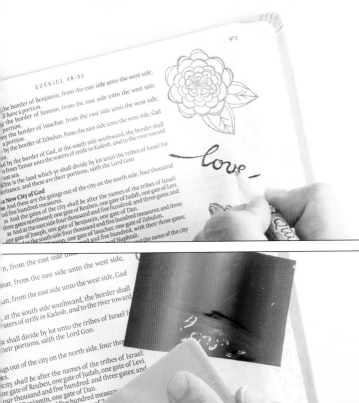

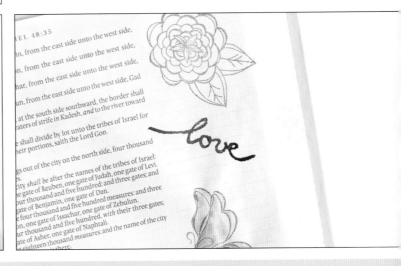

EXTRA EMBELLISHMENTS

You can add extra detail to a colored design by using gel pens. You can also add extra detail to the blank parts of the page using three-dimensional paint or glitter glue. (Products used: Sakura Gelly Roll Moonlight and Metallic gel pens, Ranger Liquid Pearls three-dimensional paint, Ranger Stickles glitter glue)

LETTERING

JOANNE FINK

Since the heart of Bible journaling involves writing God's Word, it is helpful to know some simple hand-lettered styles and how to use them. On the next few pages, you'll find several easy-to-learn lettering styles that work well on their own or can be combined to enhance and emphasize the message you are trying to convey.

SIMPLE MONOLINE CAPS

ABCDEFGHIJKLM
NOPQRSTUVWXYZ

VARY THE HEIGHT OF THESE
LETTERS TO ADD INTEREST.

Simple Monoline Mix

Aa Bb Cc Dd Ee Ff Gg Hh Ii
Jj Kk Ll Mm Nn Oo Pp Qq Rr
Ss Tt Uu Vv Ww Xx Yy Zz

THIS STYLE LOOKS BEST WHEN a
MIX OF CAPITAL AND LOWERCASE LETTERS
ARE USED IN THE SAME WORD, AND WHEN
SOME OF THE LETTERS "BOUNCE" ON THE
BASELINE, OR ARE STRETCHED VERTICALLY.

BUILT-UP ROMANS

A A A

B B B

C C C

D D D

E E E

F F F

G G G

H H H

I I I

J J J

K K K

L L L

M M M

1. **Draw the letter.** Draw the basic letter shape, sometimes known as the "skeletal" form.

2. **Add strokes.** Starting from the first point you drew, draw another stroke (or strokes) that is angled a few degrees wider than your first line, and close any open edges.

3. **Fill.** Fill the letter in with the color of your choice. Use the same color as your stroke lines for a solid letter, or use a different color for a two-toned effect.

SING
TO THE
LORD
ALL THE
EARTH
A NEW
SONG
PSALM
96:1

N N N

O O O

P P P

Q Q Q

R R R

S S S

T T T

U U U

V V V

W W W

X X X

Y Y Y

Z Z Z

Upright Script

a b c d e f g h i j k l m
n o p q r s t u v w x y z

**a b c d e f g h i j k l m
n o p q r s t u v w x y z**

handwriting

1. **Write.** Write the word out in your normal handwriting, or refer to the alphabet above.

handwriting

2. **Rewrite.** Write the word out again, this time stretching out the letters and spacing so there is a little extra space between each letter. Keep the letters connected.

handwriting

3. **Add a stroke.** Add a second stroke along the vertical lines. The goal is to leave an even amount of space between all the letters, so add the extra strokes to whichever side has the most space. Notice the first 'n': the first vertical was double stroked on the right, and the second vertical on the left.

handwriting

4. **Fill in.** Fill in the areas between the two strokes. You can use the same color as the letters or a different color for extra emphasis.

handwriting

A variation with open letters.

handwriting

The completed word, filled in.

abcdefghijklmnopqrstuvwxyz

Slanted Script

1. **Write.** Write the letters.

2. **Add a stroke.** Add a second stroke along the vertical lines.

3. **Fill.** Fill the areas between the two strokes.

CREATING FLOWING FLOURISHES

1. **Draw.** Draw a line with several loops in it.

2. **Add strokes.** Accentuate the curves by adding a second stroke along the outside edge of each curve.

3. **Fill in.** Fill in the areas between the two strokes. If the line will be a decorative accent, try filling it with a contrasting color, or with multiple colors, as shown to the left. Use the same color to attach the line to a word, as shown below.

CONTEMPORARY VERSALS

Contemporary versals are based on the enlarged eleventh-century capital letters that began a verse. These versal letters were often drawn in red or blue, with exaggerated rounded strokes, and were sometimes embellished with patterns, illustrations, and gold leaf. Contemporary versals are open letterforms that can be decorated in a variety of ways, as shown below.

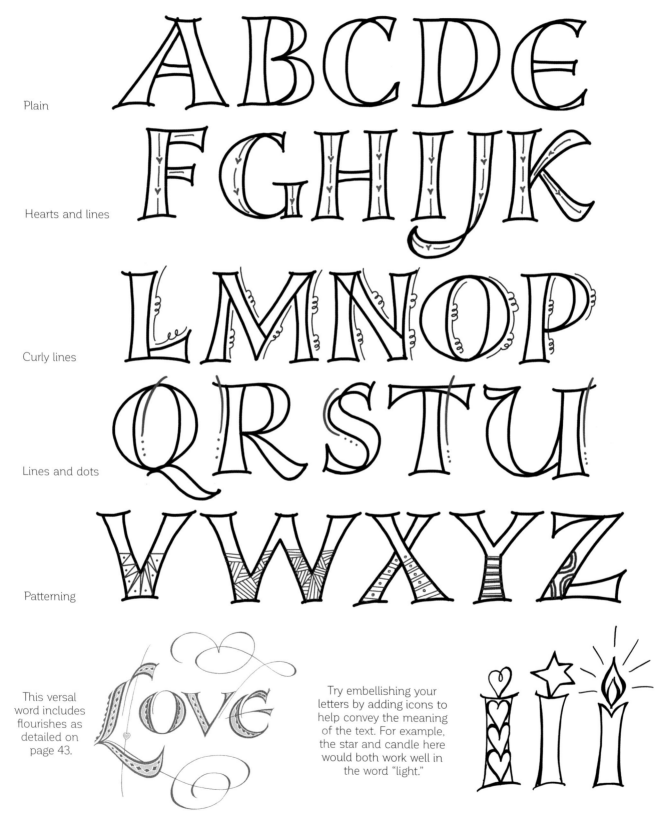

Plain

Hearts and lines

Curly lines

Lines and dots

Patterning

This versal word includes flourishes as detailed on page 43.

Try embellishing your letters by adding icons to help convey the meaning of the text. For example, the star and candle here would both work well in the word "light."

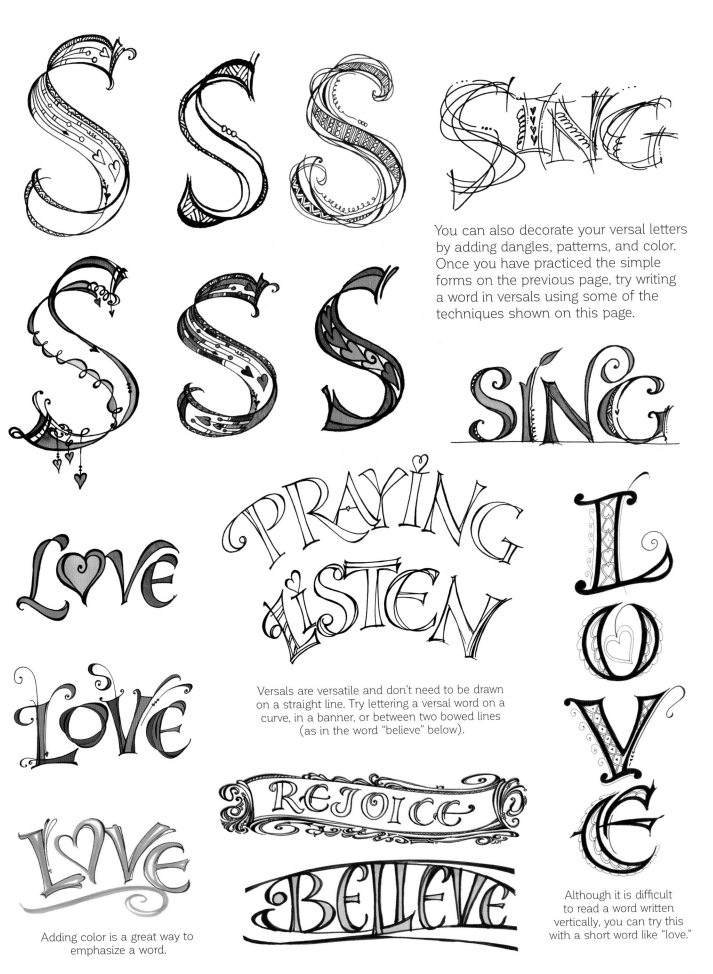

You can also decorate your versal letters by adding dangles, patterns, and color. Once you have practiced the simple forms on the previous page, try writing a word in versals using some of the techniques shown on this page.

Versals are versatile and don't need to be drawn on a straight line. Try lettering a versal word on a curve, in a banner, or between two bowed lines (as in the word "believe" below).

Adding color is a great way to emphasize a word.

Although it is difficult to read a word written vertically, you can try this with a short word like "love."

LAYOUT TECHNIQUES

JOANNE FINK

When it comes to actually sitting down and working in your Bible or journal, you'll need to make some decisions about what to write and draw, as well as how to lay out your words and images. In this section, we'll see some examples of various layouts to inspire you and get you thinking about your own work.

The real artistry of Bible journaling lies in making the text—and its important message—come alive. Asking the following questions will help you gain a more complete understanding of the text and allow you to decide how to interpret it visually.

1. What part of this text is important to me, and what do I want to emphasize?

2. What style of lettering should I use to best communicate the essence of this text?

3. Will adding color, pattern, and/or illustration enhance or distract from what I am trying to convey?

There are no right or wrong answers to these questions; they are simply a starting point for creating your personal interpretation of a particular passage.

Let's look at a simple step-by-step method for graphically laying out a piece of text.

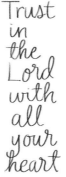

1. Write. Write the text out in your own handwriting, one word per line.

2. Capitalize. Write the text out again, this time in all capital letters.

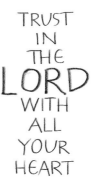

3. Emphasize. Decide which word is most important and write the text again, making that word bigger.

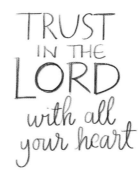

4. Adjust. Write the text again, this time emphasizing a second word and/or combining words onto single lines so the text flows.

5. Add contrast. Add contrast by changing one or more of these major elements: size, weight, color, style, or placement.

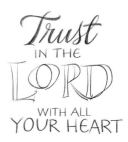

6. Try variations. Experiment by changing one or more of these elements until you are happy with your layout.

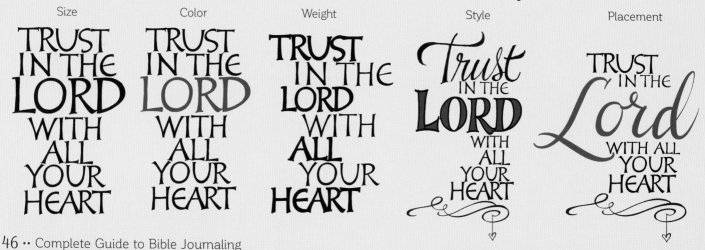

Vary these different elements to add impact and interest to your text.

| Size | Color | Weight | Style | Placement |

Continue to vary size, weight, color, style, and placement of the words until you achieve the look that expresses what's in your heart.

Don't be afraid to experiment and try a variety of layout techniques: centered, stacked, asymmetric, written on a curve, or nestled inside your illustration.

A heart icon substitutes for the word "heart" in the example below, and underscores the meaning in the example on the right.

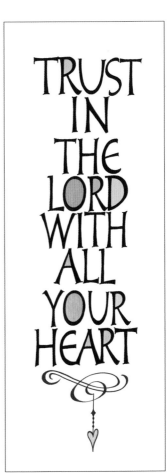

Color is a great way to add interest to any design. The three stacked examples below feature color in the interior "counter-space" of the letters. Practice lettering the same text in different ways. Elongated, scrunched, nestled... the variations are endless. The more you letter, the more confident you will become!

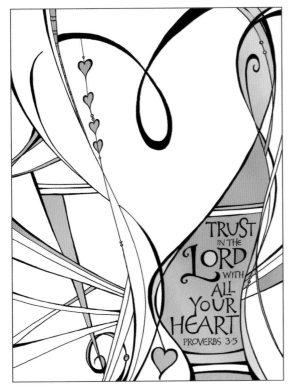

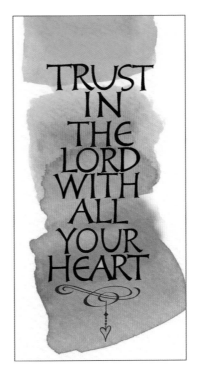

COMBINING TEXT AND ILLUSTRATION

TRY USING ONE OF THE DESIGNS IN THE BONUS SECTION AT THE BACK OF THIS BOOK AS A FOCAL POINT FOR A LAYOUT!

You can also create an illustration to go with the verse you are focusing on. Bible journaling is your time with God; what you journal in your Bible will be a visual keepsake of the connection you experience. Being able to integrate your lettering and illustration will give you the most flexibility as your interpret the scripture's meaning. Try practicing the following method of interpretive design.

1. **Write.** Write the verse and underline any words that bring an image to mind.

2. **Sketch.** Make quick thumbnail doodles of the images. A path, a lighthouse, a light bulb, a lamp, a candle, a book, and/or a set of footprints are all options for Psalm 119:105.

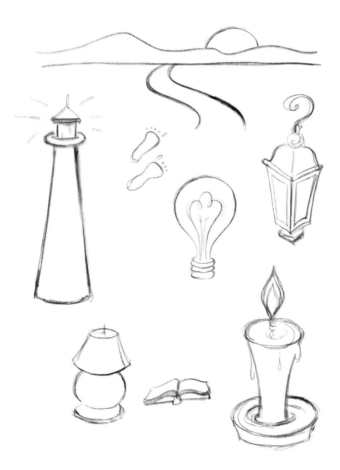

3. **Narrow down.** Review your sketches and pick a few that you are interested in exploring further.

4. **Illustrate.** Draw each option at least once.

5. **Create variants.** Decide which option best expresses what you want to convey, and draw some alternate versions of it.

6. **Pick your favorite.** Select the version you prefer. Start planning ways to integrate the scripture and your chosen illustration. Keep in mind the space where you will do your final version. If you are journaling in the margin of the Bible, aim for a long, narrow image. If you prefer to work all over the page or in an interleaved Bible, aim for a wider shape.

As you study and meditate on His Word, ask yourself what part resonates with where you are on your spiritual journey so that you can focus on creating a truly meaningful visual in your journal or Bible.

Once you have drawn your illustration, it's time to integrate it with the text. There are many ways of placing text. Try each of these methods, and then come up with some of your own ideas.

You can split the text on two sides of an illustration, as shown above, or stack the text so the words flow around part of an image, as shown below.

If you want a tall, narrow design, consider enclosing the text and illustration inside a frame designed to fit the dimensions of your space, running the text up the side, or putting the text inside the image itself.

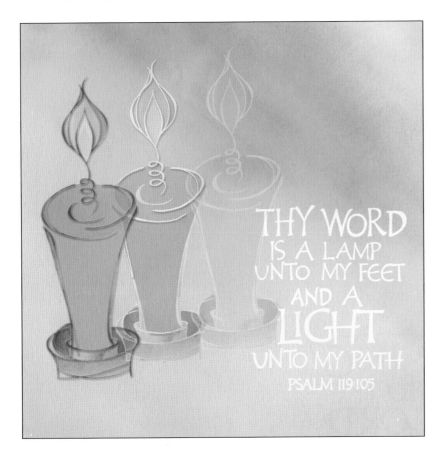

Consider overlapping the text on top of the illustration.

Think about the relative proportion of text to illustration. Do you want the text or the image to be the focal point?

SAMPLE LAYOUTS: PSALM 96

There are three main visual themes that you could consider for Psalm 96: music, singing birds, and the Earth. Here are two different interpretations of each theme.

THEME 1: MUSIC

The motifs incorporated here include a treble clef, musical notes, a staff, and a keyboard. The first version has the words flowing around the dominant keyboard shape; the second maintains a column layout.

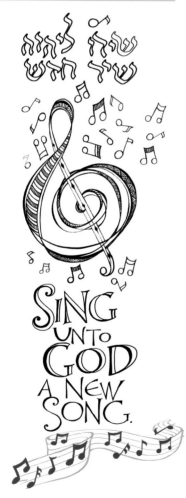

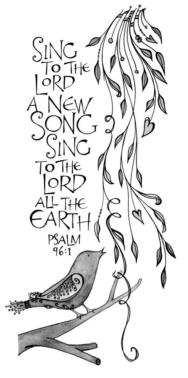

THEME 2: SINGING BIRDS

Singing birds bring these two versions of the psalm to life. One version incorporates some greenery, and the other focuses on just the birds themselves.

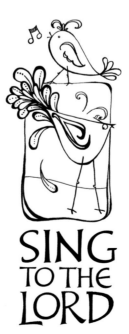

THEME 3: THE EARTH

For this motif, one version has the words nestled inside the spaces of the illustration, and the other has the words laid over top of the illustration. Consider the shape of the space you are filling in a case like this.

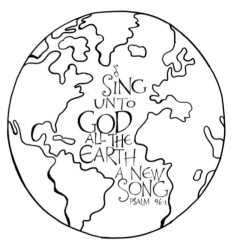

CONCEPTUAL ILLUSTRATION

How do you illustrate a text that does not include any concrete design motifs? Take Matthew 19:26, for example: it doesn't have words that bring an image to mind. The best approach in this situation is to focus on the text's meaning in hopes that an image will pop into your head. These examples—the parting of the sea, a tree growing rainbow hearts, a flower with rainbow petals, and a cross among waves (representing Jesus walking on water)— all illustrate concepts of things that are only possible with God.

Challenge: Create a unique piece of **word art** by adding a simple line drawing to a word, as shown in the "fly" butterfly and "Sabbath" candles and chalice below.

OPEN
YOUR
Heart TO
POSSIBILITY

ARTIST

FEATURED ARTISTS

The eleven artists whose work is included in this section are leaders in the exciting new Bible journaling community. While every artist has her own personal style, all have a strong heart for God's Word. As you meet each artist, you will learn a bit about how she began her Bible journaling journey, what tools she prefers, how she finds inspiration in God's Word, and what motivates her to create. Several of these artists have Bible journaling Facebook groups or other forums through which they share their art and their hearts, if you want to get to know them even better. May their words and art inspire you on your own journey!

Shanna Noel

PIONEERING A NEW WAY TO WORSHIP THROUGH BIBLE JOURNALING

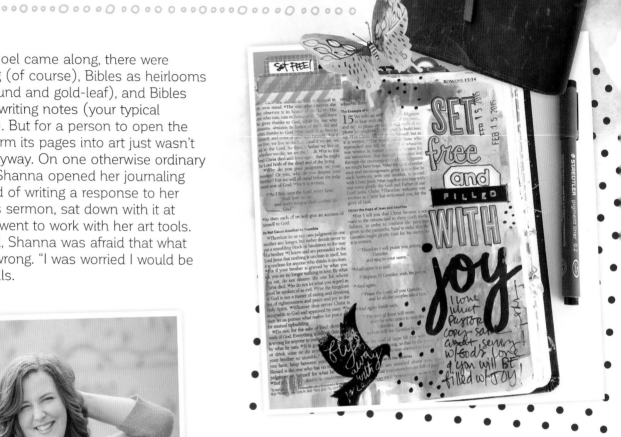

Before Shanna Noel came along, there were Bibles for reading (of course), Bibles as heirlooms (think leather-bound and gold-leaf), and Bibles with margins for writing notes (your typical "journaling" Bible). But for a person to open the Bible and transform its pages into art just wasn't done. Not yet, anyway. On one otherwise ordinary Sunday in 2014, Shanna opened her journaling Bible and, instead of writing a response to her pastor-husband's sermon, sat down with it at her art desk and went to work with her art tools. After she finished, Shanna was afraid that what she'd done was wrong. "I was worried I would be judged," she recalls.

Shanna lives with her husband and two girls in Olympia, Washington.

Hoping she wasn't the only one to have turned Bible pages into faith-centered art, Shanna searched Instagram for others who'd been moved by the same impulse. She only found a few people using ballpoint pens in the margins of journaling Bibles, and she worried about what people would think of her if she went public. Would they condemn her for defacing the Word of God? "I loved this new art form, but I was really afraid to share," Shanna says.

"I WAS INTERACTING WITH THE WORD IN THE WAY GOD HAD CREATED ME, AS A CREATIVE PERSON!"

What God was telling her was clear, however. So she took the leap of faith and published photos of her work on her blog, which quickly went viral. At first, Shanna was scared of the sudden publicity.

EZEKIEL 44:

loved

love

XO
XO
XO

in awe of

HiS

heart

XO

732

Shanna says she is so blessed to be able to bring beautiful faith-based products to the market with the help of Bella Blvd and DaySpring.

But then she realized that she was being inundated not with judgment but with enthusiasm and support. "I opened my e-mail and found it flooded with notes from women just like me who were visual learners and were excited about this idea on how to connect their faith and creativity!" Shanna says.

Art had always been part of Shanna's life, but she came to faith later than many. Shanna didn't grow up in a religious family, so it wasn't until she met a cute boy who invited her to youth group in high school that she met and fell in love with Jesus. "We are talking the years of the WWJD-bracelets-in-rainbow-order-up-my-arm type of love!" says Shanna. Amazingly, Shanna ended up falling in love with and marrying that very same cute boy, who soon became a pastor. "Jumping into being a pastor's wife as a baby Christian was one of the toughest things I think I have ever gone though. I struggled with expectations of my faith and walking my own personal walk with Christ," Shanna admits. She felt lost, and was upset with God for making her a pastor's wife, as she didn't feel like she could live up to the perceptions of the role. It wasn't until she let go of those social expectations of her faith and realized she could connect her creativity to her faith in her own unique way that she felt her heart "sing" for God again. "Once I started Bible journaling, everything changed

for me. I was hungry for the Word like I had never experienced before," she says. "I believe it was because I was interacting with the Word in the way God had created me, as a creative person!"

The rising prominence of Bible journaling as an activity and a community has taken Shanna in some interesting directions she never could have imagined. Now two years into her Bible journaling journey, Shanna is credited with bringing this form of artful worship to the attention of thousands of people while starting an international conversation about how faith and art intersect. "Honestly, if you had told me a couple of years ago I would be a business owner and traveling the world teaching, partnered with some of the most amazing companies, I would have dropped to the floor laughing!" she says. Back in 2014, she got her start with a Facebook group of about 200 women. Of course she was excited, but little did she know that God had much bigger plans for her. In the fall of 2014, she spoke at a conference about growing an online community, and afterward, many people came up to her to ask if she was doing Bible journaling full time. This got her thinking—how could she make that a reality? She felt the call, so she and her husband

For more from Shanna, visit *www.illustratedfaith.com*, follow her on Instagram at @shannanoel and at @illustratedfaith, or check her out on Facebook, YouTube, or Pinterest.

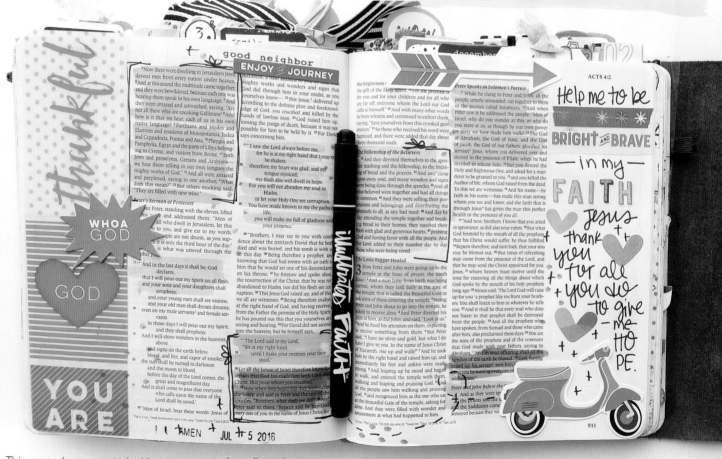

This spread was created with components from Bella Blvd's Bright & Brave Collection, which is one of Shanna's favorites. "Finding ways to be bright and brave in my faith is super important to me, and documenting that in the margins of my Bible just makes me smile!" Shanna shares.

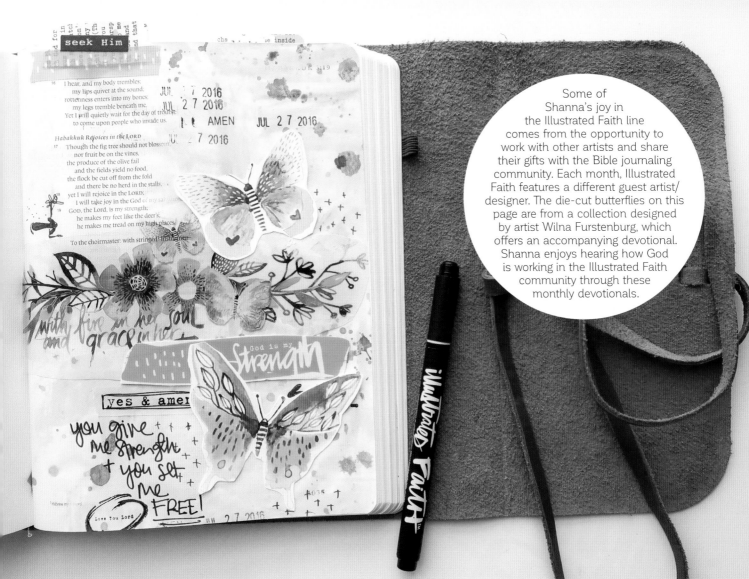

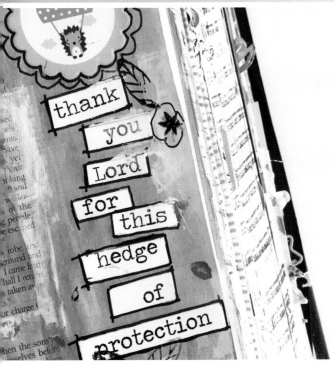

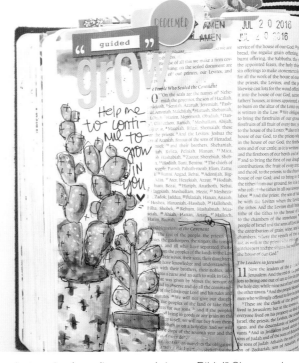

Shanna has realized that there are many sources of inspiration when it comes to deciding what to journal, including sermon notes, prayers, and devotionals. She is always looking for ideas, and sometimes even a cute little image of a hedgehog is just the inspiration she needs.

"I love using a mixed-media approach in my Bible!" Shanna shares. "Stickers, paint, paper—there are no limits! My biggest goal is to enjoy the process and not worry too much about the product."

launched Illustrated Faith and their first product, a devotional kit with stamps, in March 2015. She prayed that they would just recoup their investment in the product in the first six months. "That first product sold out in 20 minutes. And I knew right then and there that not only were we answering a need in our community, but that God was clearly guiding this," says Shanna.

She currently runs her website, *www.illustratedfaith.com*, which offers supplies, Bibles, tutorials, and even classes, and is working hard to bring Bible journaling to a global audience. Happily, she adores her new role as a teacher. "Every single day I am inspired by the Illustrated Faith community! To hear their testimonies about how this process has impacted them is something I am inspired beyond belief by. I see God working through this community in such a living, breathing way," says Shanna.

But the best thing about Bible journaling for Shanna is how it cements her personal relationship with God by forcing her to pay daily attention to His good works. "Before I started Bible journaling, I believed in God, I believed He loved me, but I had a hard time grasping just how unique and personal my relationship with God is," she says. Even just fifteen

"I SEE GOD WORKING THROUGH THIS COMMUNITY IN SUCH A LIVING, BREATHING WAY."

minutes a day of Bible journaling allows Shanna to see the presence of God in her life more clearly, and she believes that this will be the case for anyone who begins journaling. It takes a bit of commitment, but it's worth it: "When you can look back over a year of Bible journaling in a single Bible and see all the pages you have prayed over, found joy in, and grown from—there is something amazingly powerful there!" she says.

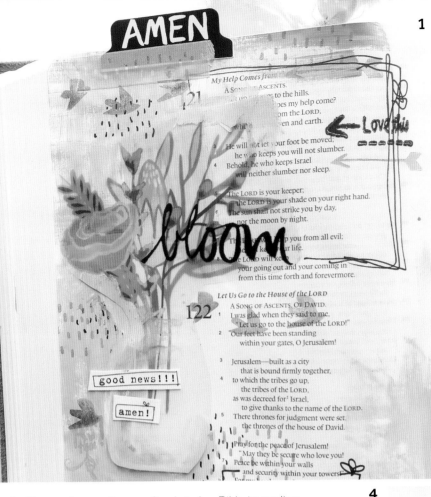

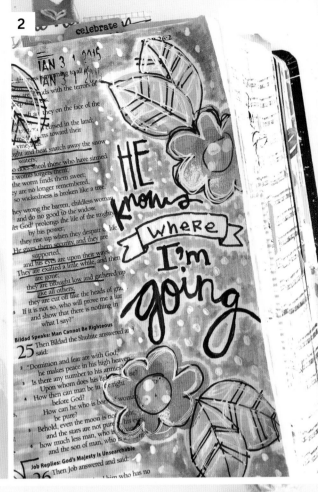

1. Shanna frequently uses florals in her Bible journaling. "I think the idea of growing and blooming as I study His Word is something that continues to connect, time and time again," she says.

2. When traveling, Shanna says, "I find myself reaching for very simple supplies. In this entry, I mainly used my journaling pen and Faber-Castell markers, which work great on these thin pages!"

3. "Don't be afraid to make a HUGE impact in those tiny two-inch margins!" Shanna encourages.

4. This page features components from Created to Create, the first devotional kit Shanna did with DaySpring. Says Shanna, "I LOVED writing it, but even more than that, I LOVED working through this Bible journaling kit with this tribe! Remember, YOU were created to create! XOX"

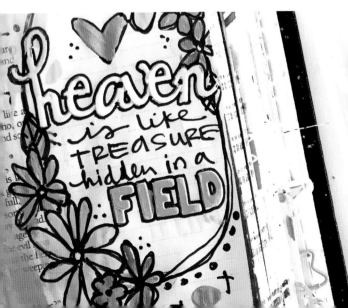

Karla Dornacher

JOURNALING TO RECONNECT WITH HER PASSION AND HER FAITH

"My very first memories as a child are of making art," says Karla Dornacher, who grew up along the Mississippi River in western Illinois. "I wanted to be an artist when I grew up, but I put my art supplies away when I became a wife and a mom, and for years I focused my creativity on my home, gardens, and crafting."

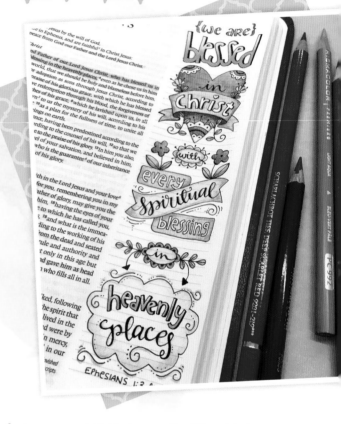

Surrounded by the beauty of the Pacific Northwest, Karla enjoys life with her husband and their two silly kitties in Vancouver, Washington.

Once upon a time, though, Karla was college-bound on a full scholarship to study art at Southern Illinois University. But weeks before her first semester, she met and fell in love with her future husband, and her life took a new direction. Soon she was married and starting a family. She and her young family moved first to the Pacific Northwest, then to Alaska for four adventurous years, and then back to Washington again. Along the way, she found another passion: her faith. In her spare time, she practiced calligraphy, using scripture as her source material.

Then, one day, something happened that brought everything together. "I was so excited the day I painted my first watercolor painting that didn't turn to mud!

I was forty years old," Karla recalls. "Combining my new love for color and my hand-lettered verses, I started my own faith-based art business, which [eventually] opened a door for me to write and illustrate more than eighteen books. Today, in some ways, I've come full circle by drawing and designing coloring books similar to those I once loved as a child, only now for the little girl that lives within us all."

A visual artist once again as well as an experienced scripture calligrapher, Karla remembers vividly the next turning point in her faith journey: discovering Bible journaling on social media in January 2015. "I was smitten!" she says. "I believe my heart skipped a beat and immediately did a happy dance! I ordered [a journaling Bible] right away; I love it because it gives me another good reason to really read and delight in God's Word and another avenue to worship Him and share Him with others."

For Karla, there's something special about her Crossway ESV Single Column Bible: it provides the

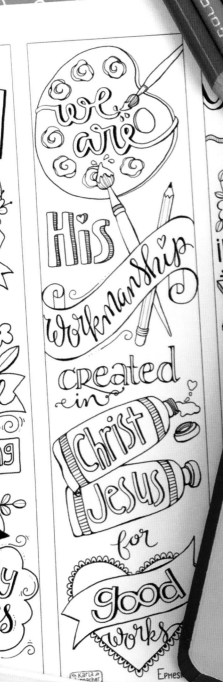

space to interact with the words artistically, which draws her in time and again. "Rather than just read and walk away, it gives me a good reason to spend more time in one passage or one verse, meditating on it and sometimes even memorizing it, which encourages my faith and draws me closer in my walk with God."

"BIBLE JOURNALING PROVIDES A WONDERFUL OPPORTUNITY FOR EVERY ARTIST—FROM BEGINNER TO ADVANCED."

Karla enjoys Bible study because she loves to dig deep into the stories and meanings—she says it feeds her mind. But she loves Bible journaling because it feeds her soul. "I tend to be a very visual person and often 'hear' God speak to me in pictures and imagery, so the art of Bible journaling has given me another new and wonderful way for me to express His Word in my own personal and unique way," she says. "I take great joy and delight in Bible journaling and illustrating scripture and am so thankful for how He has used His Word to truly transform my heart and give purpose and meaning to my life." Though she doesn't have as much time to work in her Bible as she would like, she is thankful for what time she does get, typically a few days a week. She sticks to a simple toolkit consisting of a light pencil for sketching, a pen for inking, and colored pencils for coloring.

To people just beginning to get into Bible journaling, she says, "Just be you, and don't worry about being perfect, because nothing is perfect apart from God!" She cautions journalers to not compare themselves to others, but to develop their own style and process. For example, she can be inspired by someone's scrapbook-style Bible journaling work, but she wouldn't imitate it because it's not her own personal style—she doesn't even own stamps! "But the great thing is that there is no single style that is better than another," she says. "Bible journaling provides a wonderful opportunity for every artist—from beginner to advanced—to learn and grow and develop her own skills and style [while] creatively connecting with the Lord."

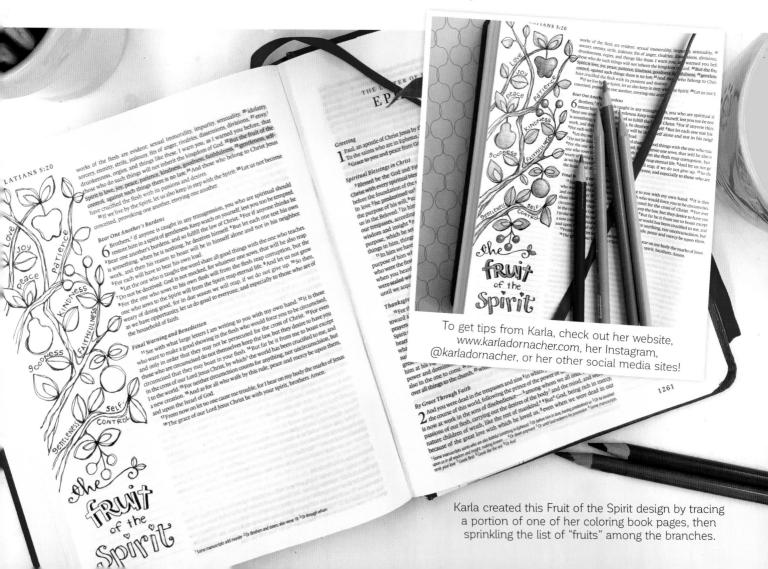

To get tips from Karla, check out her website, www.karladornacher.com, her Instagram, @karladornacher, or her other social media sites!

1261

Karla created this Fruit of the Spirit design by tracing a portion of one of her coloring book pages, then sprinkling the list of "fruits" among the branches.

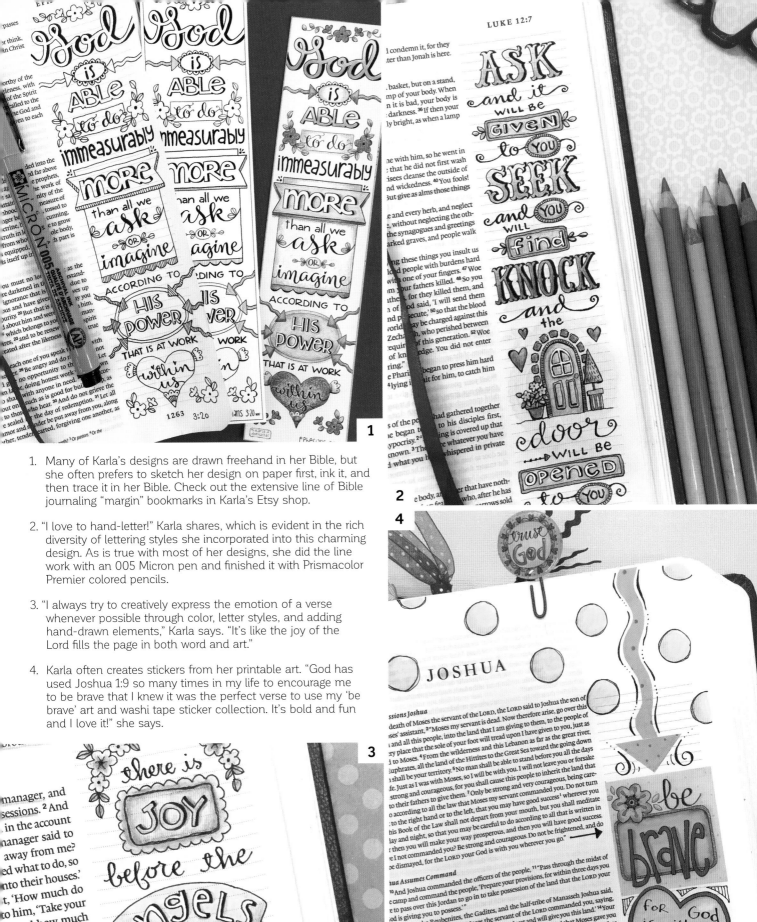

1. Many of Karla's designs are drawn freehand in her Bible, but she often prefers to sketch her design on paper first, ink it, and then trace it in her Bible. Check out the extensive line of Bible journaling "margin" bookmarks in Karla's Etsy shop.

2. "I love to hand-letter!" Karla shares, which is evident in the rich diversity of lettering styles she incorporated into this charming design. As is true with most of her designs, she did the line work with an 005 Micron pen and finished it with Prismacolor Premier colored pencils.

3. "I always try to creatively express the emotion of a verse whenever possible through color, letter styles, and adding hand-drawn elements," Karla says. "It's like the joy of the Lord fills the page in both word and art."

4. Karla often creates stickers from her printable art. "God has used Joshua 1:9 so many times in my life to encourage me to be brave that I knew it was the perfect verse to use my 'be brave' art and washi tape sticker collection. It's bold and fun and I love it!" she says.

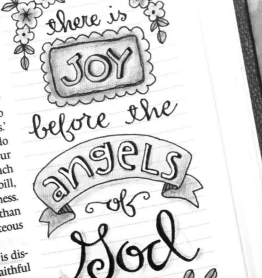

Valerie Sjodin

JOINING GOD AND SELF, WORD AND IMAGE

Valerie Sjodin came to Bible journaling as a result of a serious shoulder injury that prevented her from painting. After having followed her childhood dream to become an artist, earning a degree in painting and then teaching middle- and high-school art for ten years, this was a serious blow. "For nearly a year I couldn't hold a brush to an easel. I thought I would never create again," she says. But she found a way, even with her very limited range of motion, by doodling in small boxes. Doodling became journaling, and the rest is history. "Art journaling changed my life. Now I can't imagine life without it," she says.

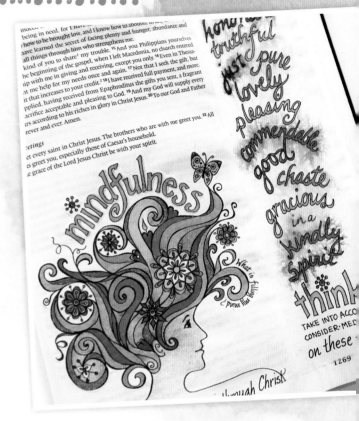

Valerie lives an artful life with her enthusiastic husband in the beautiful Pacific Northwest community of Hillsboro, Oregon.

Valerie eventually incorporated Bible journaling into her life in early 2015, after years of working in separate journals. Like many other beginning Bible journalers, Valerie was at first unsure about working directly in a book that contains the Word of God. But that changed when she encountered Rebekah R Jones' series of Bible Art Journaling Challenges (learn more about Rebekah on page 92).

"WHEN I AM DOING BIBLE JOURNALING, I SENSE GOD'S PRESENCE AND PLEASURE."

Rebekah's exercises and writings, Valerie says, "gave me courage to jump in and actually do art in my Bible." She was still careful not to douse the pages with too much ink or shred them with aggressive penmanship, though; her style was—and continues

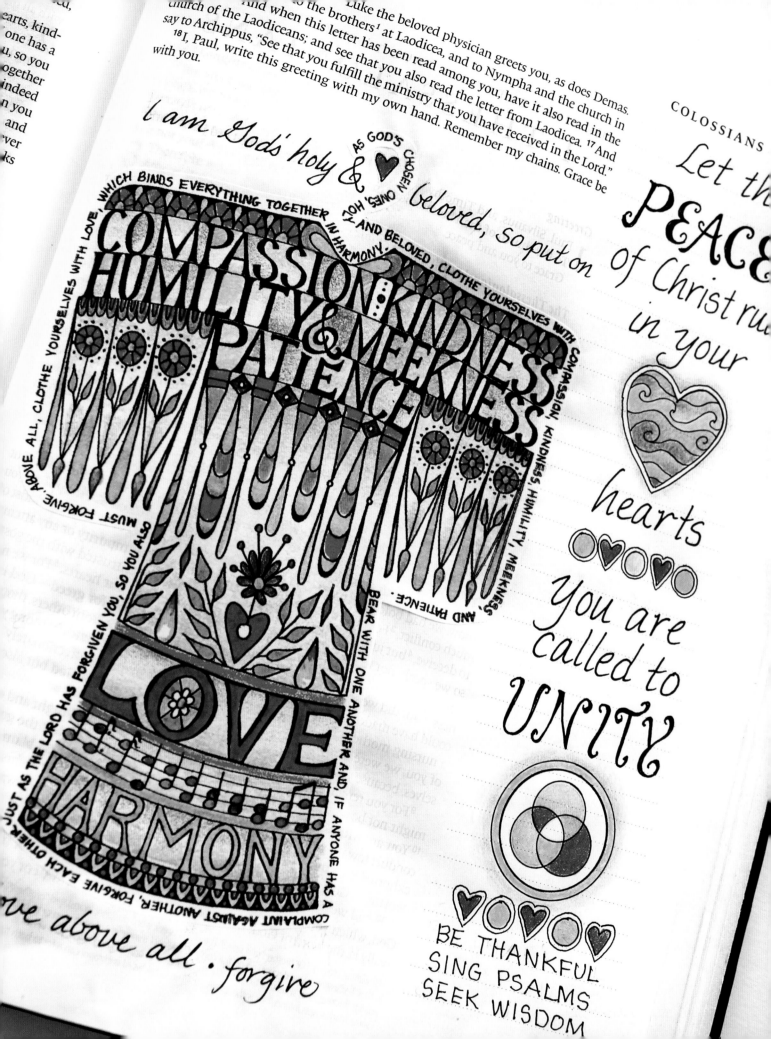

Luke the beloved physician greets you, as does Demas. And when this letter has been read among you, have it also read in the church of the Laodiceans; and see that you also read the letter from Laodicea. 17 And say to Archippus, "See that you fulfill the ministry that you have received in the Lord." 18 I, Paul, write this greeting with my own hand. Remember my chains. Grace be with you.

I am Gods' holy & ♥ beloved, so put on

AS GOD'S CHOSEN ONES, HOLY AND BELOVED, CLOTHE YOURSELVES WITH COMPASSION, KINDNESS, HUMILITY, MEEKNESS, AND PATIENCE.

CLOTHE YOURSELVES WITH LOVE, WHICH BINDS EVERYTHING TOGETHER IN HARMONY.

COMPASSION & KINDNESS
HUMILITY & MEEKNESS
PATIENCE

ABOVE ALL, CLOTHE YOURSELVES WITH LOVE

MUST FORGIVE

LOVE

HARMONY

JUST AS THE LORD HAS FORGIVEN YOU, SO YOU ALSO

COMPLAINT AGAINST ANOTHER, FORGIVE EACH OTHER

BEAR WITH ONE ANOTHER AND, IF ANYONE HAS A

ve above all · forgive

Let the PEACE of Christ rule in your hearts

you are called to UNITY

BE THANKFUL
SING PSALMS
SEEK WISDOM

to be—characterized by finesse. Once she has laid down the art and color, she usually writes the results of word studies she has done on her chosen passage in the margins, creating a multilayered textual and visual response to her Bible study.

It is this experience of meetings, between God and self and between word and image, that makes Bible journaling irresistible to a visual learner like Valerie. "When I don't do it for a while, I miss spending time with God in that way," she says. "When I am doing Bible journaling, I sense God's presence and pleasure, [the] Holy Spirit speaking to my spirit."

Valerie's personal approach to a Bible journaling session is unique. "As I read a passage of scripture, I imagine myself in the passage. If it's a narrative, I imagine myself as one of the people in the scene. If there is a truth to receive, I imagine holding out my hands, receiving and asking, 'Now what?' From this, a word, a picture, or an idea is highlighted," she says. For example, when she was journaling 2 Corinthians 3:18, what came to her mind was a butterfly's metamorphosis, because years ago, she had purchased a chrysalis and watched it transform into a butterfly. She had drawn each phase of the transformation, so she had readily available artistic references, as well as her own memory, to draw from.

Valerie's Bible journaling is not the only aspect of her life that combines faith and art; this combination was also the source of a very powerful moment for her in a different setting. She once attended a prophetic art workshop in which the participants had to ask God for an image to give to a stranger as a blessing. As Valerie was unfamiliar with the concept and uncomfortable with approaching people in the street, she was hesitant to engage with the activity. Nevertheless, she completed the task, asking God for inspiration and drawing what came—and she was stunned at the result. "That little drawing spoke so specifically to the person I gave it to that it had to be God," says Valerie. "In that moment of tearful gratitude, I saw how God could use the visual language along with [His] written language as a way to speak and bless His children." This is just one of the many things that have encouraged Valerie in her faith-based art, and one of the many reasons she continues to share it with others.

Look for Valerie's three books (*Colorful Blessings, Colorful Blessings: Celebrating Everyday Wonders,* and *Paintings, Prayers & Passages*), and visit her website, *www.valeriesjodin.com.*

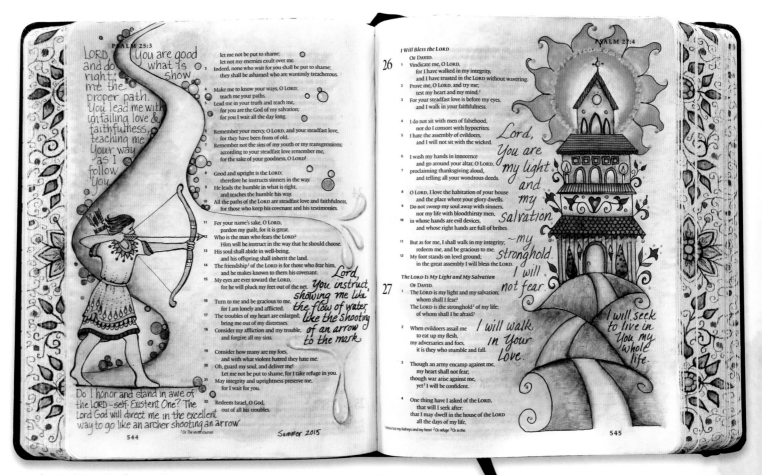

In studying this Psalm, Valerie found the Lord's instructions were like the shooting of an arrow to the mark, and incorporated that imagery into the page.

For Valerie, sketching out and lettering scripture is her way of meditating upon the verse, and adding text to her Bible pages is more than a reference; it's a call to action. Valerie's favorite journaling tools are Micron pens (005 or 01), Faber-Castell Pitt XS pens, and Prismacolor colored pencils.

1. Valerie painted this image on deli paper and wrote the accompanying prayer to reflect her desire to be poured out for Jesus.

2. This page was done with acrylic glazing, a pen, and acrylic paints. The Messianic seal, an image found in Jerusalem combining the most ancient symbols of Judaism (menorah) and Christianity (fish), speaks to Valerie of powerful Messianic prophecies foretold and fulfilled in Jesus Christ, while the path symbolizes the way to the truth.

3. The metaphor Valerie finds in the scripture text inspires her imagery, and she designs the lettering style of key words to reflect its meaning. She usually includes definitions and synonyms for her key word, as she did for the word "abide."

4. "Journaling this page was scary and risky, outside my comfort zone and messier than my usual style," Valerie says, "which seemed fitting for the message of the cross. The redemption of the page reminds me of the redemption I have because of the blood Jesus sacrificed for me."

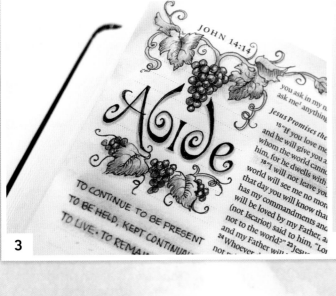

Sephra Travers

DEALING WITH STRESS THROUGH DAILY JOURNALING

Sephra Travers' journey to Bible journaling began with a fundamental human need: she was going through a very stressful time due to her son's medical issues, and she wanted to find a hobby to relieve that stress. Somewhat restored by the effects of the Zentangle® meditative drawing method, she continued looking for new techniques to try. Her awareness of the soothing possibilities of art expanded further when she discovered Joanne Fink's YouTube tutorials. "Once I started drawing, I was hooked!" she says. Next, Sephra added calligraphy to her artistic regime.

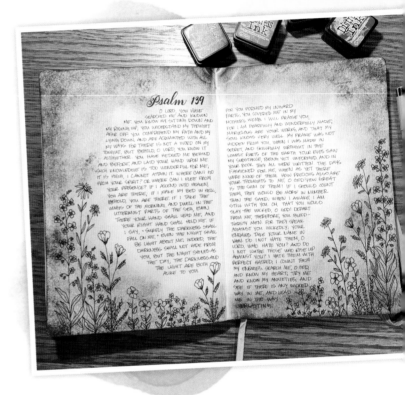

Sephra loves living in Soldotna, Alaska with her husband and two children.

And then she came across Bible journaling—which, in a way, she had already enjoyed as a child. "When I was young, I loved to keep a journal," she says. "But instead of journaling about my thoughts, I'd write song lyrics, scripture, and study notes from church.

"BIBLE JOURNALING IS POWERFUL BECAUSE GOD'S WORD IS POWERFUL."

Now that I'm an adult, I've found that there's an actual Bible journaling community out there full of inspiring people." By participating in online drawing challenges and networking with other artists on social media, Sephra turned her art hobby into a daily habit. Her ability to cope with stress vastly improved, and now she never misses a day. "It has become my therapy and meditation each night," she says. "If I'm

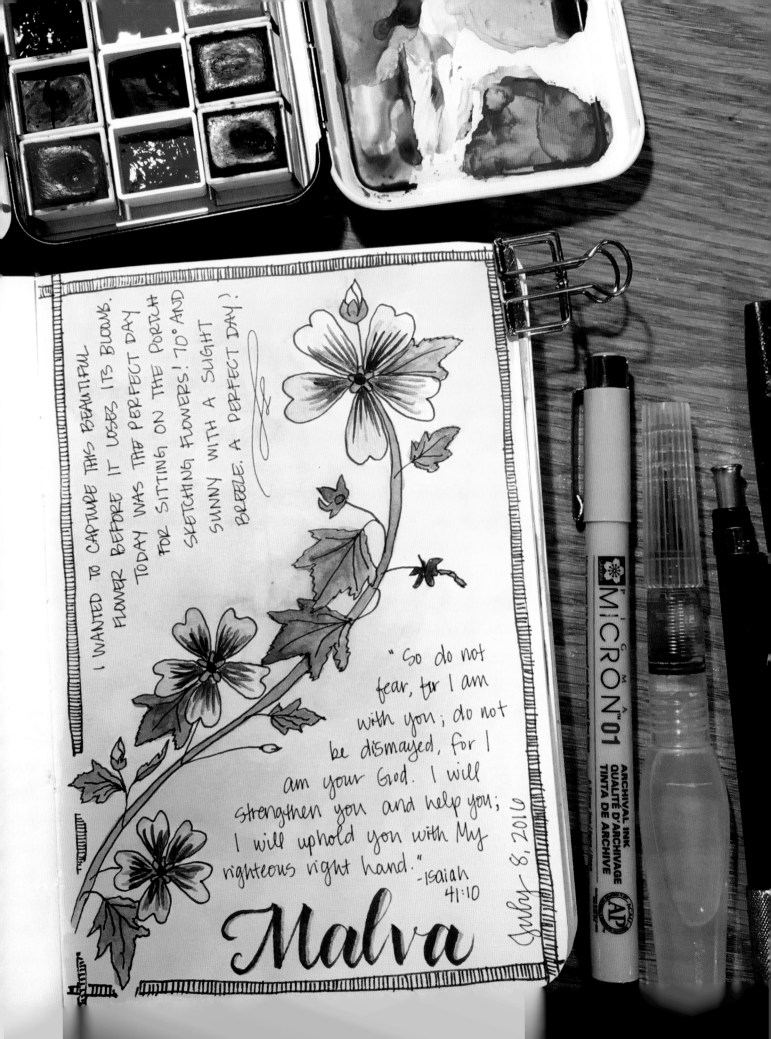

I WANTED TO CAPTURE THIS BEAUTIFUL
FLOWER BEFORE IT USES ITS BLOOM.
TODAY WAS THE PERFECT DAY
FOR SITTING ON THE PORCH
SKETCHING FLOWERS! 70° AND
SUNNY WITH A SLIGHT
BREEZE. A PERFECT DAY!

"So do not
fear, for I am
with you; do not
be dismayed, for I
am your God. I will
strengthen you and help you;
I will uphold you with My
righteous right hand."
—Isaiah
41:10

July 8, 2016

Malva

feeling stressed, all I need to do is spend time writing out a verse or song and it helps me put things in perspective."

By helping her step out of her troubles, Bible journaling allows Sephra to more easily connect with God. The hard part is finding the time and space to get immersed in it. "I'm a night owl, so I do most of my creating after my kids go to bed. I sit at my desk, turn on some music, and start drawing and writing," she says. The quiet of the house and lack of distractions allow her to really sink into what she is doing and absorb the meaning and emotions. She also finds it helpful to keep the creative juices flowing by committing to a monthly challenge or following a theme. "That way, I know which direction I am going and avoid drawing a blank on what I want to do," she says.

Sephra usually embellishes her Bibles and faith journals with artistic script rather than images; for the past year, she's been improving her lettering skills. She uses light, smooth colors to background the bold, flowing strokes of her pens, and often she'll draw and color simple illustrations, such as flowers, to adorn her writing. The effect—and her goal—is to draw attention to the words themselves. "I learn and retain information best with visual and tactile methods," she says. "So, by physically writing scripture, I am able to

learn and remember so much more. Plus, the colorful lettering or drawing that I add to the verse triggers my memory in a visual way."

For Sephra, Bible journaling is all about the combination of God and self. "Bible journaling is powerful because God's Word is powerful. Any time you devote to reading and studying the Bible is going to change your life, if you let it," she says. "[And] art is powerful because it's a form of self-expression. Ultimately, the idea is to have your self-expression coincide with God's Word."

In the end, for Sephra, art and Bible journaling are not something to be done in a vacuum, or a journey to experience alone. The monthly or daily Bible journaling challenges, which she finds readily on Instagram, keep her on her toes, and she recommends that other Bible journalers give them a try. Plugging into the Bible journaling community helps her "stay accountable and encouraged," she says. "There are so many wonderful groups out there with people who are eager to share tips and keep you inspired."

If you'd like to join Sephra in her journey, visit her online at www.sephrassketchbook.wordpress.com or on Instagram at @sephras_sketchbook.

1

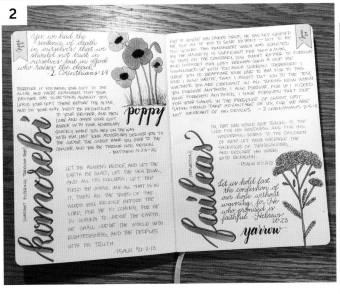

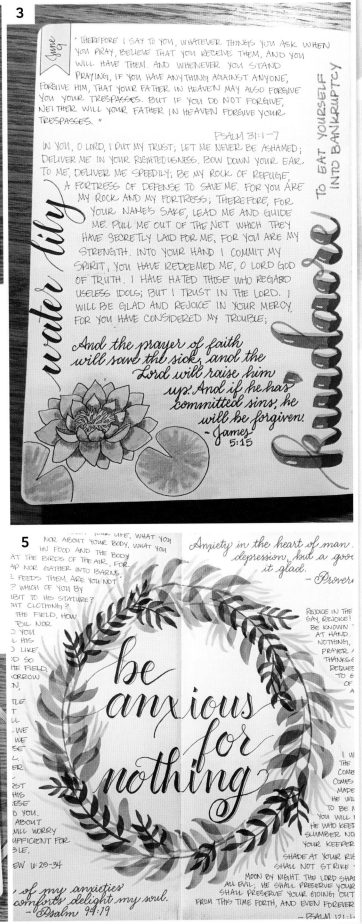

1. One of Sephra's favorite combinations is handwriting with a basic watercolor illustration. "I think it adds a simple kind of beauty to the text without taking the focus away from the words," she shares. "I used a Tombow brush marker for the bold lettering, watercolor for the leaves, a fountain pen for the cursive text, and a .25 tipped Pentel Slicci pen for the other text."

2, 3, 4. Sephra was inspired by Instagram prompts to create these three journal entries using her favorite tools: Tombow brush markers for the bold brush lettering, watercolors for the flower illustrations, and different pens for the scripture writing. "I love the combination of those three elements on a sketchbook page," she says. "I had never heard of some of the flower prompts; finding an image to try and draw from was part of what made these pages so fun to do."

5. This striking design is one of Sephra's favorites, because she lettered her "go-to" verses around the wreath for when she's feeling stressed or worried.

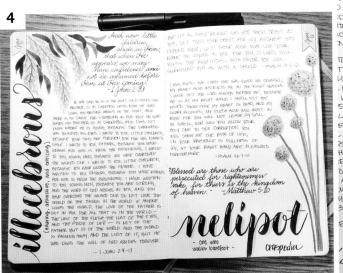

Valerie Wieners-Massie

LEARNING GOD'S WORD THROUGH BIBLE JOURNALING

Valerie Wieners-Massie has been creating art since she was a little girl. It was her therapy and way of expressing herself. "I've never really used a lot of words. I like to call myself an extreme introvert, so art has been the way that I have always spoken," says Valerie. "If I was in a dark time, my art would be dark, and if everything was great, then my art would have a cheerful look to it." Valerie went to college on an art scholarship, but then her life took a turn for the worse, and she dropped out after a year. After a childhood and young adulthood spent struggling with eating disorders and substance abuse, Valerie ended up in a Christian rehabilitation center when she was twenty-one years old. "I didn't believe in God at the time, but during my forty-five days there, I had a change of heart," says Valerie.

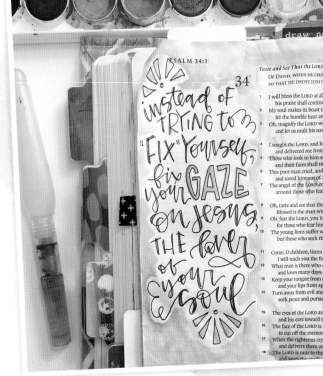

Valerie currently resides in Amarillo, Texas, with her husband, Brad, and son, Oliver.

At the same time, Valerie reconnected with her love of art, deciding to be productive instead of destructive and create things from the heart. So she turned her focus to hand lettering and began selling paintings through Facebook. Three years ago, with the help of a friend, she created her website, and now works full time as an artist out of her home in Amarillo, Texas. "God has definitely blessed [my work]," she says. "I have learned a lot and love

"I HAVE LEARNED SO MUCH SCRIPTURE THROUGH WRITING THE WORDS AND PAINTING THE PAGES."

sharing tips and tricks with people. I want to inspire and help people be more creative because I believe that everyone can be creative."

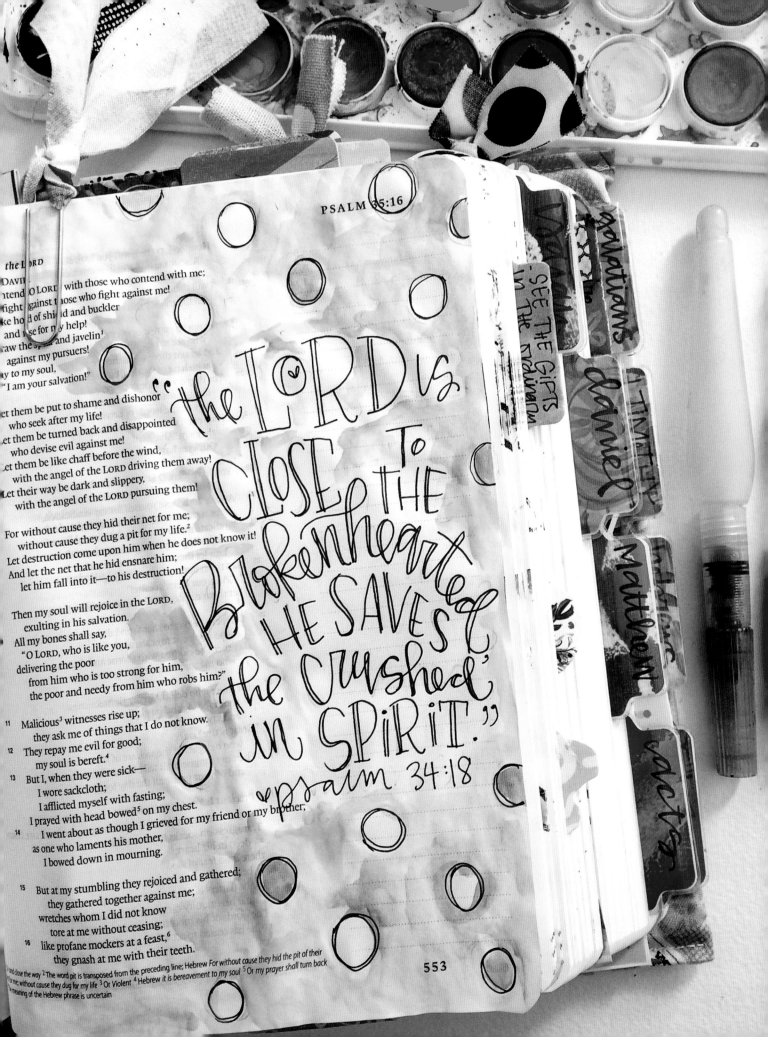

the LORD

[Of] DAVID. [Co]ntend, O LORD, with those who contend with me;
fight against those who fight against me!
[Ta]ke hold of shield and buckler
and rise for my help!
[D]raw the spear and javelin[1]
against my pursuers!
[S]ay to my soul,
"I am your salvation!"

[Le]t them be put to shame and dishonor
who seek after my life!
[L]et them be turned back and disappointed
who devise evil against me!
[L]et them be like chaff before the wind,
with the angel of the LORD driving them away!
[L]et their way be dark and slippery,
with the angel of the LORD pursuing them!

For without cause they hid their net for me;
without cause they dug a pit for my life.[2]
Let destruction come upon him when he does not know it!
And let the net that he hid ensnare him;
let him fall into it—to his destruction!

Then my soul will rejoice in the LORD,
exulting in his salvation.
All my bones shall say,
"O LORD, who is like you,
delivering the poor
from him who is too strong for him,
the poor and needy from him who robs him?"

11 Malicious[3] witnesses rise up;
they ask me of things that I do not know.
12 They repay me evil for good;
my soul is bereft.[4]
13 But I, when they were sick—
I wore sackcloth;
I afflicted myself with fasting;
I prayed with head bowed[5] on my chest.
14 I went about as though I grieved for my friend or my brother;
as one who laments his mother,
I bowed down in mourning.

15 But at my stumbling they rejoiced and gathered;
they gathered together against me;
wretches whom I did not know
tore at me without ceasing;
16 like profane mockers at a feast,[6]
they gnash at me with their teeth.

"the LORD is close to the Brokenhearted, He saves the Crushed in spirit."
psalm 34:18

[1] and close the way [2] The word pit is transposed from the preceding line; Hebrew For without cause they hid the pit of their
[net] for me, without cause they dug for my life [3] Or Violent [4] Hebrew it is bereavement to my soul [5] Or my prayer shall turn back
[6] the meaning of the Hebrew phrase is uncertain

Valerie also started Bible journaling two years ago, after seeing Shanna Noel's work and joining her Illustrated Faith movement. "I didn't always go to church, so reading the Bible and learning scripture was really hard for me," explains Valerie. "When I saw this form of worship I was like, 'This is for me!' and got my Bible and started. Since then I have learned so much scripture through writing the words and painting the pages." Basically, Bible journaling combines two of the most important things in her life: "I love creating and I love Jesus. Give me paints and pens and I can be busy for hours," she says.

Now deep into her third journaling Bible, Valerie says that Bible journaling has been one of the biggest things that has grown her faith and trust in God, and working in her Bible is a daily habit that she doesn't want to break. "I believe that reading and being in the Word is super important to life, so I make it a priority," she says. She also likes to share her love for Bible journaling with others, by posting to Instagram and Facebook and talking with her fellow churchgoers. "I'm always down to talk supplies with people!" she says. But she doesn't pressure herself to fill any particular page, and she doesn't always know what she'll illustrate when she sits down to do it. "As I am reading in my Bible, if a verse pops out to me, I will letter it in the margins. A lot of times I will read and

nothing pops, so those pages are blank," Valerie says. "I can always go back and do something later, but that day I will just leave it blank."

Valerie has two key pieces of advice for beginning Bible journalers. First, she encourages people to figure out what mediums are their personal favorites. "I'm not lying when I say I have thousands of dollars of art supplies in my art room, and I always go back to my $4 pan of watercolors, my $3 pencil, and my $14 set of markers," Valerie says. "That is what works for me, but each person is different."

Her other piece of advice is that everyone should find their own style, rather than copying others' pages. "If you are always trying to copy someone else, you are going to find yourself always coming up short, because it doesn't look like [what you are copying]," she says. "You are the only you on the earth, and you make an awful version of someone else. If you're always trying to imitate someone else's style, you'll never find your own—you'll never be able to offer your own gift to the world." This actually connects to one of Valerie's favorite verses: Psalm 139:14. "It has been one of the first verses I have journaled in each of my Bibles. I think it's a critical chapter for all of us to remember—God made each one of us beautiful and unique," she says.

On Valerie's site, www.ValerieWienersArt.com, you'll find three lettering guides on different types of hand-lettered alphabets and doodles, as well as scrap packs and other things you can use in your Bible. Also check her out on Instagram at @valeriewieners.

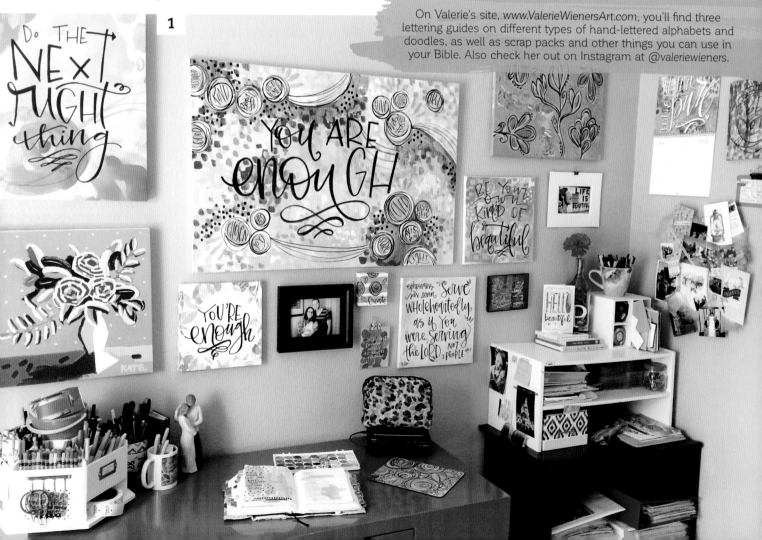

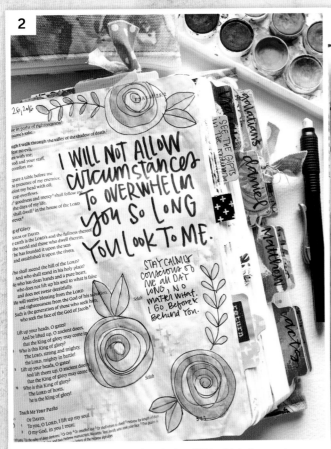

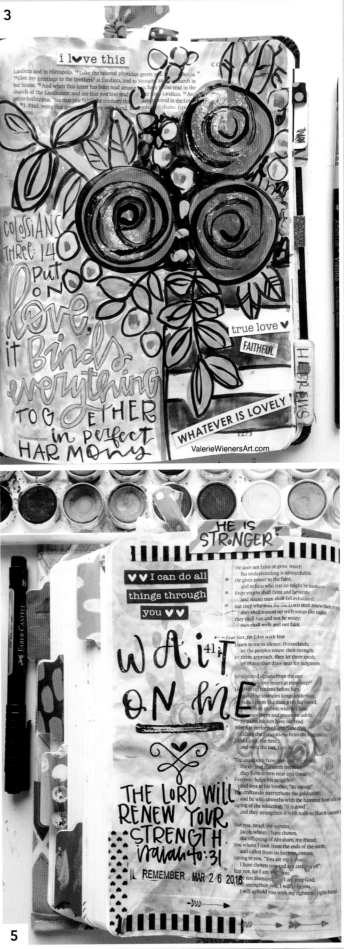

In addition to journaling in her Bible, Valerie creates empowering message paintings, such as the ones seen on the wall of her studio (image 1), which she also offers as downloadable Bible journaling prints in her online store, www.valeriewienersart.com. Her go-to tools are watercolors and Faber-Castell pens, which she used to create images 2, 4, and 5. Her early pages were predominantly done in the margins of her journaling Bible, but today Valerie boldly covers much of the page with her acrylic paintings, as shown in image 3.

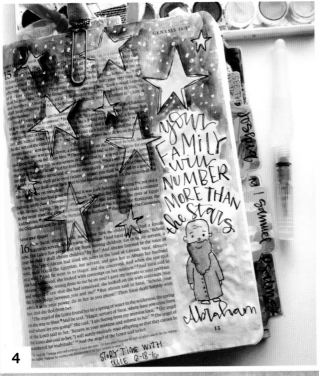

Rebecca Rios

FROM CRAFTS TO BIBLE PAGES

Rebecca Rios has always been creatively inclined, spending time making a variety of things. She's a retired pastry chef, crocheter, scrapbooker, and photographer, as well as a homeschool teacher. "I've always been amazed at taking raw supplies and turning them into something beautiful," she explains.

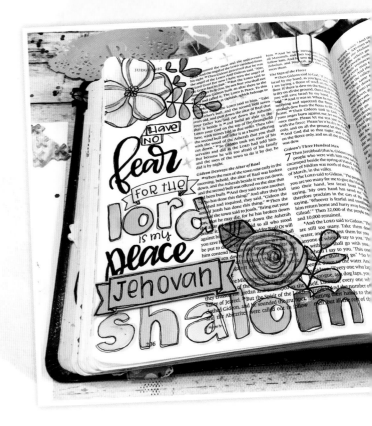

A Northern Illinois native, Rebecca enjoys crafting, laughter, and drinking copious amounts of tea.

So, of course, she knew right away, when she first came across it, that Bible journaling was a natural fit for her. But she was intimidated at first—her specialty was pastries, after all, not visual art. Nevertheless, she needed to find a way into it: no other art so easily intertwined creativity and faith. She started cautiously, at first sticking to imitating pages that she had found on Pinterest or other sites, rather than drawing from her own life and experiences. Over time, though, her methods changed. More than a year after starting, working week-by-week and page-by-page, she has completely filled her journaling Bible with original art. "I love color and making something beautiful with His precious Words!" she says.

But Bible journaling is more than just making art, Rebecca stresses. "Bible journaling connects a very big part of who I am—the creative part—back to God, and it's this interaction that makes the Word come alive for me," she says. "I love the fact that each page is a representation of time that I've spent with the Lord and is a chronicle of what He was teaching me in those moments."

"THE PAGE IS *NOT* THE FINISHED PRODUCT—YOUR HEART CHANGE IS."

The journaling process makes Rebecca slow down to really take in the verses. She describes it as "dwelling," since the act of creating art takes much longer than just jotting down a few notes

my **help** comes from **LORD** who made **heaven** & **earth**

PS. 121:2

The sun shall not strike you by day,
nor the moon by night.

The LORD will keep you from all evil;
he will keep your life.

The LORD will keep
your going out and your coming in
from this time forth and forevermore.

Let Us Go to the House of the LORD

122 A SONG OF ASCENTS. OF DAVID.

I was glad when they said to me,
"Let us go to the house of the LORD!"

Our feet have been standing
within your gates, O Jerusalem!

Jerusalem—built as a city
that is bound firmly together,

to which the tribes go up,
the tribes of the LORD,
as was decreed for Israel,
to give thanks to the name of the LORD.

There thrones for judgment were set,
the thrones of the house of David.

Pray for the peace of Jerusalem!
"May they be secure who love you!

Peace be within your walls
and security within your towers!"

For my brothers and companions' sake
I will say, "Peace be within you!"

For the sake of the house of the LORD our
God,
I will seek your good.

Our Eyes Look to the LORD Our God

123 A SONG OF ASCENTS.

To you I lift up my eyes,
O you who are enthroned in the heavens!

Behold, as the eyes of servants
look to the hand of their master,
as the eyes of a maidservant
to the hand of her mistress,
so our eyes look to the LORD our God,
till he has mercy upon us.

Have mercy upon us, O LORD, have mercy
upon us,
for we have had more than enough of
contempt.

Our soul has had more than enough
of the scorn of those who are at ease,
of the contempt of the proud.

Our Help Is in the Name of the LORD

124 A SONG OF ASCENTS. OF DAVID.

If it had not been the LORD who
was on our side—
let Israel now say—
if it had not been the LORD who was on
our side
when people rose up against us,
then they would have swallowed us up
alive,
when their anger was kindled against
us;

then the flood would have swept us away,
the torrent would have gone over us;
then over us would have gone
the raging waters.

Blessed be the LORD,
who has not given us
as prey to their teeth!

We have escaped like a bird
from the snare of the fowlers;
the snare is broken,
and we have escaped!

Our help is in the name of the LORD,
who made heaven and earth.

The LORD Surrounds His People

125 A SONG OF ASCENTS.

Those who trust in the LORD are
like Mount Zion,
which cannot be moved, but abides forever.

As the mountains surround Jerusalem,
so the LORD surrounds his people,
from this time forth and forevermore.

For the scepter of wickedness shall not rest
on the land allotted to the righteous,
lest the righteous stretch out
their hands to do wrong.

Do good, O LORD, to those who are good,
and to those who are upright in their
hearts!

But those who turn aside to their crooked
ways
the LORD will lead away with evildoers!
Peace be upon Israel!

Restore Our Fortunes, O LORD

126 A SONG OF ASCENTS.

When the LORD restored the fortunes of Zion,
we were like those who dream.

just breathe

about a passage. She explains, "I spend a lot more time just sitting in His presence and soaking up the scriptures." This closely recorded engagement with holy text has significantly improved Rebecca's Bible fluency, allowing her to remember full verses more easily because of the ties she has woven between the art and her heart. But she often also journals thoughts and prayers in her Bible rather than scripture (as seen in every sample on this spread except at bottom right).

These days, she has more contentment in her life and much more confidence in her Bible journaling—though it's not always easy for her to find the time or space to do it. Nevertheless, she manages to fit it in. "As a busy mom and wife, I often have to split my Bible art into mini sessions, reading a devotional in the morning, sketching out my page later, adding ink, and finally putting color and embellishments on the page," she says.

She has developed an approach that feels as natural as breathing to her. First, she settles on a verse or a series of verses to illustrate. Sometimes this decision is easy. Other times, when it's not, she'll simply open to a random page and pray for God's guidance on how to proceed. Once she feels comfortable in a certain location in the Bible, she lets her creativity take over, allowing her supplies to guide her. "I'll pick a medium, usually based on my mood. Sometimes, I'll have a new technique I want to try, or new stamps that I can't wait to use, so that will inform my style for the page," she says. "Lately I enjoy adding drawings—and I'm *not* skilled in that area—so I'm Googling, 'how to draw X,' or 'how to doodle Y.'"

Her recommendations for beginners are to pick up as large a set of colored pencils as they can afford and to stick to a softcover, single-column journaling Bible, since its flexible spine will make it easier to add chunky embellishments in a scrapbooking style. But no matter what Bible you own or what tools for creating you prefer, what's important for beginning Bible journalers, as Rebecca has learned, is balancing technique with confidence. "Comparison is the thief of joy," says Rebecca. "The page is *not* the finished product—your heart change is. Don't lose sight of the fact that this should be worship."

Follow Rebecca on Instagram at @ps348girl and see her stamp designs at the Sweet 'n Sassy Stamps website, www.sweetnsassystamps.com.

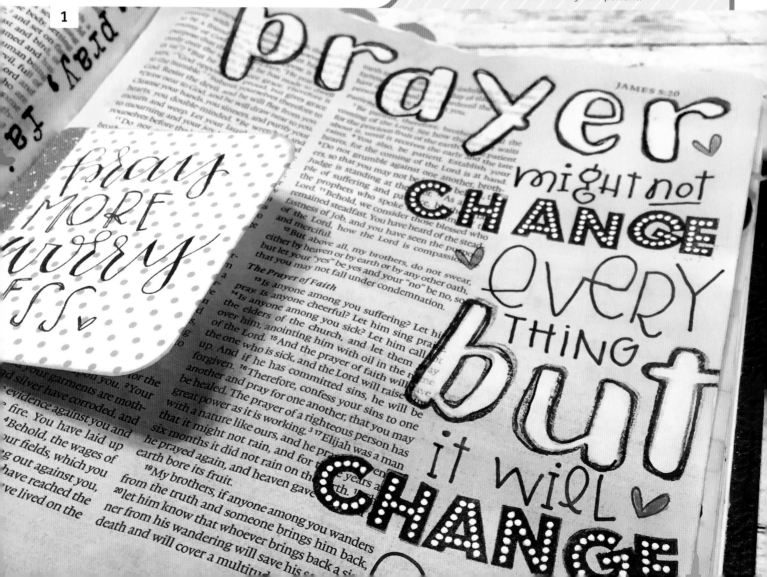

1

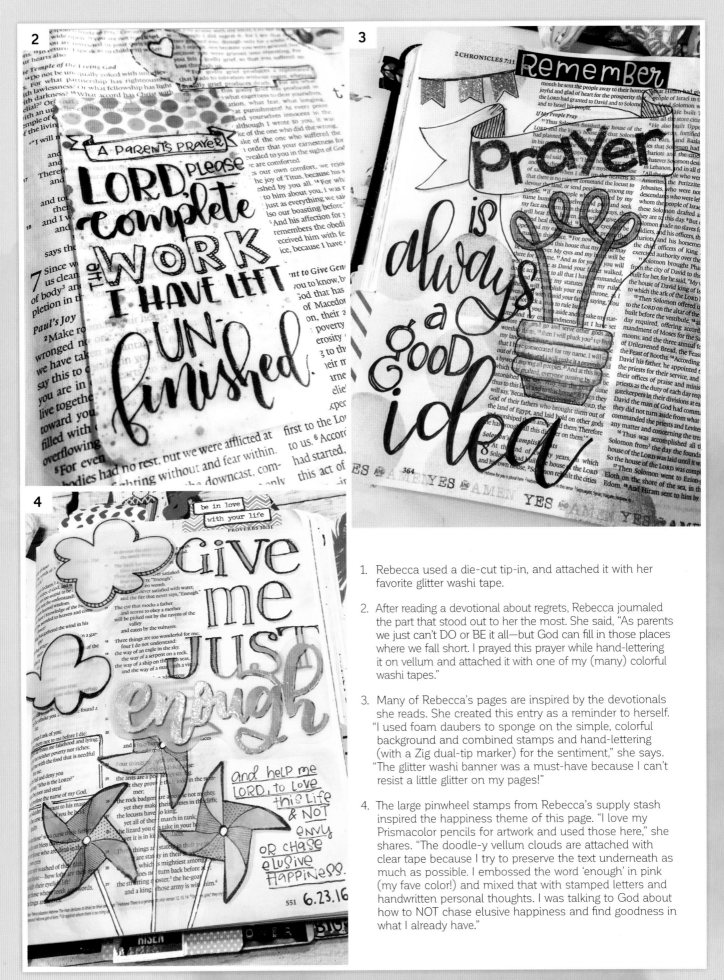

1. Rebecca used a die-cut tip-in, and attached it with her favorite glitter washi tape.

2. After reading a devotional about regrets, Rebecca journaled the part that stood out to her the most. She said, "As parents we just can't DO or BE it all—but God can fill in those places where we fall short. I prayed this prayer while hand-lettering it on vellum and attached it with one of my (many) colorful washi tapes."

3. Many of Rebecca's pages are inspired by the devotionals she reads. She created this entry as a reminder to herself. "I used foam daubers to sponge on the simple, colorful background and combined stamps and hand-lettering (with a Zig dual-tip marker) for the sentiment," she says. "The glitter washi banner was a must-have because I can't resist a little glitter on my pages!"

4. The large pinwheel stamps from Rebecca's supply stash inspired the happiness theme of this page. "I love my Prismacolor pencils for artwork and used those here," she shares. "The doodle-y vellum clouds are attached with clear tape because I try to preserve the text underneath as much as possible. I embossed the word 'enough' in pink (my fave color!) and mixed that with stamped letters and handwritten personal thoughts. I was talking to God about how to NOT chase elusive happiness and find goodness in what I already have."

Tai Bender

FINDING A NEW CRAVING FOR GOD'S WORD THROUGH BIBLE JOURNALING

Before Tai Bender discovered Bible journaling, "reading my Bible was a 'have to,' not a 'get to.' I wanted desperately to fall in love with the Word of God. I prayed that I would crave the words," she says. So Tai didn't hesitate to follow her impulse when she stumbled across Bible journaling on Instagram one fateful day in 2014, ordering a journaling Bible within minutes after her discovery. She just knew that it was a form of worship she had to try, that it could be the answer to her prayer. As soon as the Bible arrived, she set to work with what she had at home at the time—one pen and a set of inexpensive colored pencils. It turned out this was a turning point for Tai, as Bible journaling has changed her life and given her the amazing opportunity to share the love of God through her art and the Word.

Tai lives with her husband, Paul, and two children, Elijah and Lauren, in Newark, Ohio, where she enjoys studying the Word and helping to lead Sunday worship as a vocalist in her church band.

A self-taught artist, Tai works at her kitchen table at her home in Newark, Ohio; her pantry doubles as her art supply cache. "My house looks like Hobby Lobby threw up in it!" she jokes. It's a simple setup.

"JUST GET IN THERE! ROCK WHAT YOU GOT!"

And that's the way it should be, she believes, because what's important is not having a slick studio or sophisticated tools or training, but rather practicing one's love for the Word. Bible journaling helps Tai bring the spiritual and creative components of her personality into harmony, and she wants to spread that feeling to others. "Just get in there!" she urges would-be Bible journalers. Don't wait for the perfect time, setting, or inspiration: "Rock what you got!"

During hard times, Tai might journal a verse that is comforting to her. Other times, she responds

Beautiful

♥ sing

PSALM 50:16

"all the birds of the hills all that moves in the field is mine"

Lord I worship you because you are sovereign now. you have all authority over all praise the Lord. AMEN

Printed Bible text (Psalm 49–50):

3 My mouth shall speak wisdom;
 the meditation of my heart shall be...
 I will incline... to a proverb;
 I will solve... to the music of...
 ...of trouble,
 ...those who cheat...
 ...in their wealth
 and boast of the abundance of their
 riches?
7 Truly no man can ransom another,
 or give to God the price of his life...
 for the ransom of their life is costly...
 and can never suffice,
 that he should live on forever
 and never see the pit.
 For he sees that even the wise die...
 the fool and the stupid alike...
 ...and leave their wealth to others.
11 Their graves are their homes forever,
 their dwelling places to all generations,
 though they called lands by their own
 names.
12 Man in his pomp will not remain;
 he is like the beasts that perish.
13 This is the path of those who have foolish
 confidence;
 yet after them people approve of their...

God Himself Is Judge
A Psalm of Asaph.
50 The Mighty One, God the LORD,
 speaks and summons the earth
 from the rising of the sun to its setting.
Out of Zion, the perfection of beauty,
 God shines forth.

Our God comes; he does not keep silence;
 before him is a devouring fire,
 around him a mighty tempest.
He calls to the heavens above
 and to the earth, that he may judge his
 people:
"Gather to me my faithful ones,
 who made a covenant with me by
 sacrifice!"
The heavens declare his righteousness,
 for God himself is judge!

7 "Hear, O my people, and I will speak;
 O Israel, I will testify against you.
 I am God, your God.
8 Not for your sacrifices do I rebuke you;
 your burnt offerings are continually
 before me.
9 I will not accept a bull from your house
 or goats from your folds.
10 For every beast of the forest is mine,
 the cattle on a thousand hills.
11 I know all the birds of the hills,
 and all that moves in the field is mine.
 ...were hungry, I would...
 the world and...
 ...the flesh...

artistically to prayers, song lyrics, a verse, or her sermon notes from church. Daily Bible reading and journaling help her recharge her faith. She loves journaling with bold, bright colors and glitter, and uses stickers and stamps on almost every page. This may explain why her favorite journaling Bible—the one she ordered on the day she discovered Bible journaling—is bursting at the seams. It's no museum artifact, though—she still creates in it. "I love it because it is so chubby and full of paint and prayers and tears," she says. She also likes to journal in hymnals, as seen in the sample below.

Tai has even personally seen the way that faith-inspired art can be a gateway to salvation—her son was saved through art, in a way. One night ten-year-old Elijah drew a picture of a cross on a hill. After he was in bed, the Holy Spirit told Tai to call him in to her. She asked him to explain his picture, and Elijah described the Crucifixion story and that Jesus had died to save us all. "I told him that sometimes when you grow up in a Christian house, you might feel like you have always been a Christian, but to truly be a Christian, you have to confess your sins and ask God for forgiveness," Tai says. "He said he wanted to do that. He prayed his very own prayer admitting he is a sinner, asking forgiveness, and asking for salvation! That night my baby was saved. God chose me to present the Gospel to my child through art worship. It just doesn't get any better than that!"

Online, Tai shares her creativity through YouTube, Periscope, her blog, and Instagram. She has also taken her stamp art expertise to the next level, designing and selling her own line of faith-centric stamps. And in spring 2017, she'll be collaborating with other artists to run a multiday creative worship retreat. But in the end, Tai doesn't Bible journal because of her success, or because it's fun, or because it exercises her creativity, or because she's proud of the end result. She does it because her relationship with the Word and with God is so full, as full as her stuffed-to-the-gills Bible. "My relationship is full, my heart is full, my home is full, my joy is full," she says. "I am able to fall deeper into Jesus every time I open the pages, splash some paint, stamp a sentiment." For Tai, Bible journaling is art with a purpose, and she believes it has a positive role to play in our society: "I hope and pray you are encouraged to use your talents to sprinkle Jesus all over your life and the lives of everyone with whom you come in contact!"

For more from Tai, visit her website at www.growingmeadows.com, follow her on Instagram at @growingmeadows, or check her out on Facebook, Pinterest, or YouTube.

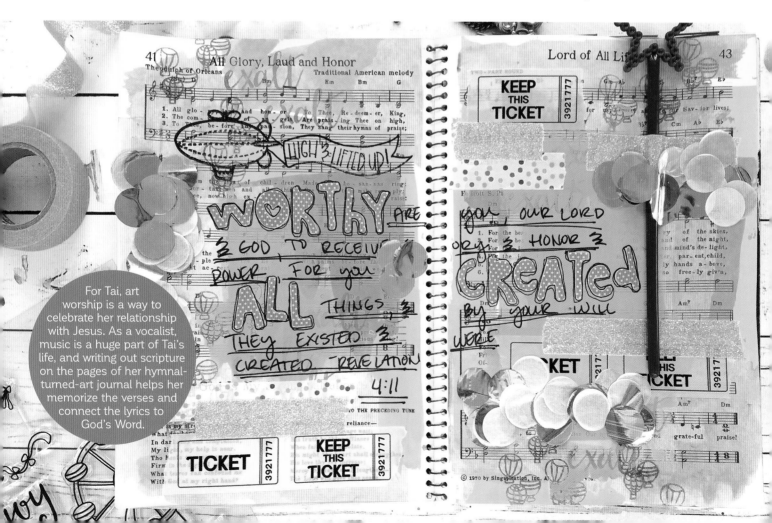

For Tai, art worship is a way to celebrate her relationship with Jesus. As a vocalist, music is a huge part of Tai's life, and writing out scripture on the pages of her hymnal-turned-art journal helps her memorize the verses and connect the lyrics to God's Word.

1. Tai really enjoys studying Greek and Hebrew meanings for words we see in our modern Bibles. On this page, she wanted to capture how the Greek uses just one word, "Tetelestai," to sum up the work of Christ: IT IS FINISHED.

2. Psalm 147 is a particular favorite of Tai's, reminding us of the amazing greatness of God, who holds the whole world in His hands, numbers the stars, and calls them by name.

3. Tai says, "This is a small selection of my worship journals and journaling Bibles. The Bible on the far right is my most-loved. Believe it or not, it is one of the original small-sized ESV journaling Bibles. This Bible is more than double its original size! These books are full of artwork, prayers, notes, glitter, tear stains, and crumbs. My Bible makes me happy, not because it is so full, but because my relationship with the Word, the living God, my Jesus is so FULL!"

4. "Galatians 2:15–21 is one of my favorites!" Tai shares. "I love how Paul uses the word 'justified' so many times. He is our Kinsman Redeemer; we are joint heirs forever with the living Son of God!"

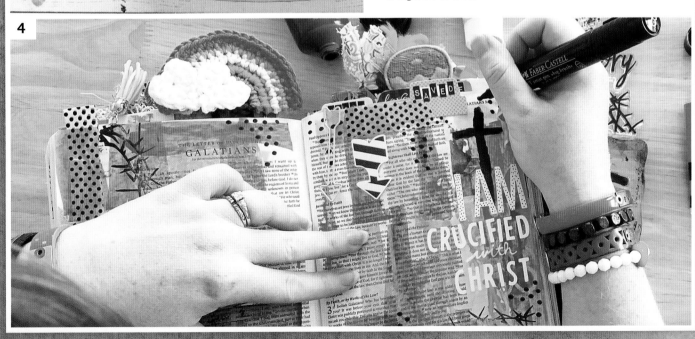

Krista Hamrick

USING HER PROFESSIONAL TALENT FOR GROWTH WITH GOD

Krista Hamrick never considered any career other than being an artist. After graduating from Moore College of Art and Design in 1988, she worked for many years as a staff artist in a small illustration studio designing gift products and party ware before transitioning to being an independent artist. "Back in 1988, I was cautioned by my studio to avoid subjects that were too religious," Krista says. "Over the years, the market has changed significantly, while at the same time my art has evolved to reflect my Christian faith more and more."

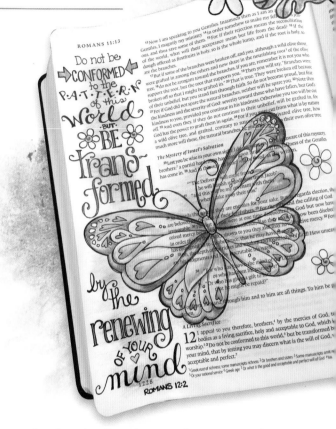

Krista lives near Philadelphia, Pennsylvania, with her husband and two teenage sons. "My work tends to be swirly and pretty to counteract all that manliness," she says.

Krista, who has been illustrating in her Bible since February 2015, is a self-proclaimed Bible study junkie and was amazed when she discovered Bible journaling while browsing on Pinterest. "I immediately knew I needed a hobby. What an awesome idea—a Bible sketchbook! It certainly hit home for me," she says.

As a professional artist, the creative process is different for her work versus her journaling. "In my commercial projects, the formulation of ideas is never easy. I sit and sketch, get up and pace, make notes, get up and rummage through the cabinets for chocolate, sit and research, get up and make coffee, make a reference board, and then, once I reach the required level of artistic angst, I can finally focus and begin to turn out marketable work," she laughs.

"GOD IS DOING A GREAT THING WITH BIBLE JOURNALING!"

But her process for Bible journaling is exactly the opposite. "Almost every page has been inspired by something I came across in my day-to-day life that reminded me of a passage, or scripture that just needed to be expressed in my Bible," says Krista. "For example, singing in the car with my son to a popular

GENESIS

The Creation of the World

1 In the beginning, God created the heavens and the earth. 2 The earth was without form and void, and darkness was over the face of the deep. And the Spirit of God was hovering over the face of the waters.

3 And God said, "Let there be light," and there was light. 4 And God saw that the light was good. And God separated the light from the darkness. 5 God called the light Day, and the darkness he called Night. And there was evening and there was morning, the first day.

6 And God said, "Let there be an expanse[1] in the midst of the waters, and let it separate the waters from the waters." 7 And God made[2] the expanse and separated the waters that were under the expanse from the waters that were above the expanse. And it was so. 8 And God called the expanse Heaven.[3] And there was evening and there was morning, the second day.

9 And God said, "Let the waters under the heavens be gathered together into one place, and let the dry land appear." And it was so. 10 God called the dry land Earth,[4] and the waters that were gathered together he called Seas. And God saw that it was good. 11 And God said, "Let the earth sprout vegetation, plants[5] yielding seed, and fruit trees bearing fruit in which is their seed, each according to its kind, on the earth." And it was so. 12 The earth brought forth vegetation, plants yielding seed according to their own kinds, and trees bearing fruit in which is their seed, each according to its kind. And God saw that it was good. 13 And there was evening and there was morning, the third day.

14 And God said, "Let there be lights in the expanse of the heavens to separate the day from the night. And let them be for signs and for seasons,[6] and for days and years, 15 and let them be lights in the expanse of the heavens to give light upon the earth." And it was so. 16 And God made the two great lights—the greater light to rule the day and the lesser light to rule the night—and the stars. 17 And God set them in the expanse of the heavens to give light on the earth, 18 to rule over the day and over the night, and to separate the light from the darkness. And God saw that it was good. 19 And there was evening and there was morning, the fourth day.

20 And God said, "Let the waters swarm with swarms of living creatures, and let birds[7] fly above the earth across the expanse of the heavens." 21 So God created the great sea creatures and every living creature that moves, with which the waters swarm, according to their kinds, and every winged bird according to its kind. And God saw that it was good. 22 And God blessed them, saying, "Be fruitful and multiply and fill the waters in the seas, and let birds multiply on the earth." 23 And there was evening and there was morning, the fifth day.

24 And God said, "Let the earth bring forth living creatures according to their kinds—livestock and creeping things and beasts of the earth according to their kinds." And it was so. 25 And God made the beasts of the earth according to their kinds and the livestock according to their kinds, and everything that creeps on the ground according to its kind. And God saw that it was good.

26 Then God said, "Let us make man[8] in our image, after our likeness. And let them have dominion over the fish of the sea and over the birds of the heavens and

1 Or a canopy; also verses 7, 8, 14, 15, 17, 20 2 Or fashioned; also verse 16 3 Or Sky; also verses 9, 14, 15, 17, 20, 26, 28, 30; 2:1 4 Or Land; also verses 11, 12, 22, 24, 25, 26, 28, 30; 2:1 5 Or small plants; also verses 12, 29 6 Or appointed times 7 Or flying things; see Leviticus 11:19–20 8 The Hebrew word for man (adam) is the generic term for mankind and becomes the proper name Adam

1

Christian song precipitated an idea. As did the story that my other son told me about an experience he had as a camp counselor. Inspiration is everywhere."

Krista is thrilled that so many people are drawn to interacting with God's Word and sharing it with others. "God is doing a great thing with Bible journaling!" she says. For her, Bible journaling is an act of worship. "To be able to spend time in the presence of God, meditating on and illuminating a verse, is an awesome experience," she says. As a former Sunday school teacher, Krista does love the intellectual challenge of Bible study, but she loves Bible journaling for different reasons. "Bible journaling is more about just coming before God and opening myself up to enjoying Him. Hand lettering a verse, taking the time to craft each word, allows the scripture to settle deeply in my heart and allows me a chance to listen to what the Spirit stirs up," she says.

Because her journaling sessions are usually the result of a spark of inspiration, Krista puts no expectations on herself about how often she works in her Bible, sometimes illustrating several pages in the span of a few days and sometimes going for a month without journaling. One particularly powerful Bible journaling session stands out in her memory: the time she was driven to journal Psalm 13. "After a series of deeply distressing news events occurred in rapid succession, my heart was broken for the condition of the world. From my gut I cried out, 'How much more of this can happen? When will it end?'" says Krista. But when she read Psalm 13—including the Psalmist's words, "How long, O Lord?"—she was comforted. "If I care about the condition of my fellow men, how much more does our Creator care for us and redeem us?" she asked herself. "I visualized myself clinging to the world, surrounded and upheld by God's steadfast love."

For others interested in Bible journaling, Krista advises that you just start. "Don't be afraid!" she says. "It's all about getting into God's Word and creating from your experience with Him there. You can't mess it up. There are no rules. There are no comparisons."

Visit Krista at her website, www.kristahamrick.com. You can also find her on Facebook and Pinterest!

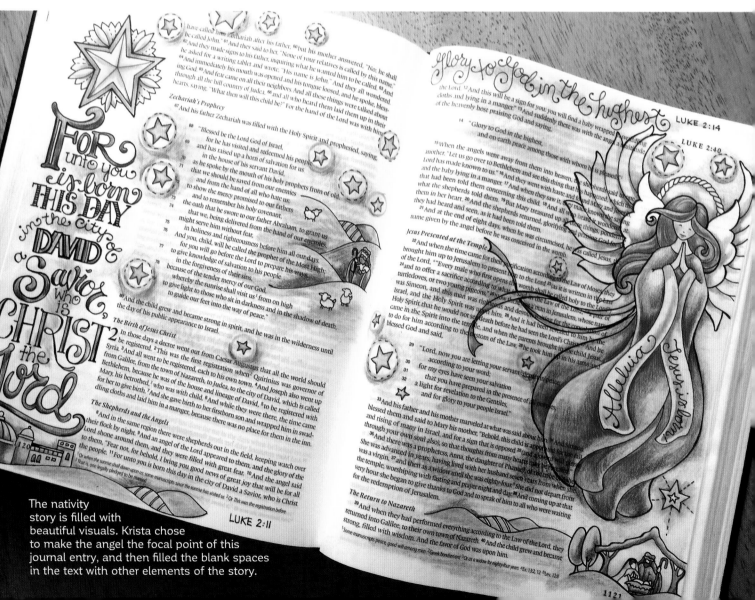

The nativity story is filled with beautiful visuals. Krista chose to make the angel the focal point of this journal entry, and then filled the blank spaces in the text with other elements of the story.

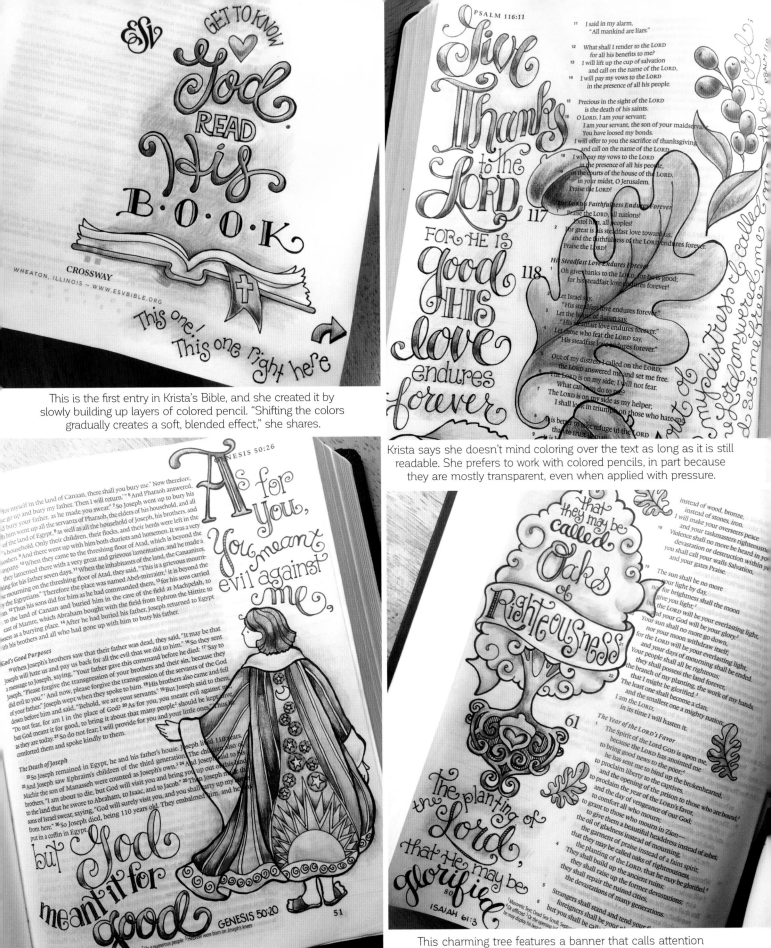

This is the first entry in Krista's Bible, and she created it by slowly building up layers of colored pencil. "Shifting the colors gradually creates a soft, blended effect," she shares.

Krista says she doesn't mind coloring over the text as long as it is still readable. She prefers to work with colored pencils, in part because they are mostly transparent, even when applied with pressure.

Krista's gorgeous illustration of Joseph began as a pencil sketch, then was inked and colored with layers of colored pencils. She says, "I enjoyed decorating his robe with symbols from one of his dreams, and the twenty pieces of silver (that his brothers sold him for) are along the hem."

This charming tree features a banner that calls attention to the concept Krista was drawn to illustrate the day she created this journal entry. "A passage may have so much imagery that it is difficult to decide what to focus on. Choose the one that strikes you today," Krista advises. "You can always add a tip-in or an illustrated bookmark later."

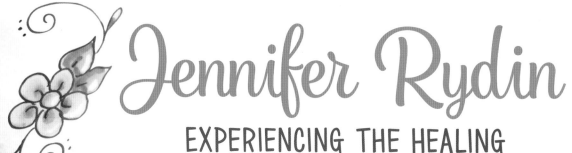

Jennifer Rydin

EXPERIENCING THE HEALING POWER OF BIBLE JOURNALING

Two years ago, Jennifer Rydin was at a place in her life where she wanted to go deeper in her faith. After searching for a way to get where she wanted to be, her "a-ha!" moment came while she was surfing Instagram hashtags like #biblejournaling and #illustratedfaith. To her, Bible journaling felt very new and yet familiar at the same time. "I grew up with a mother who loved studying scripture," says Jennifer. "She would combine God's Word with artistic lettering and display it in frames around our house." Like mother, like daughter! Jennifer shares that "there was something deep inside of me that longed to express God's promises through the beauty of ink and paint."

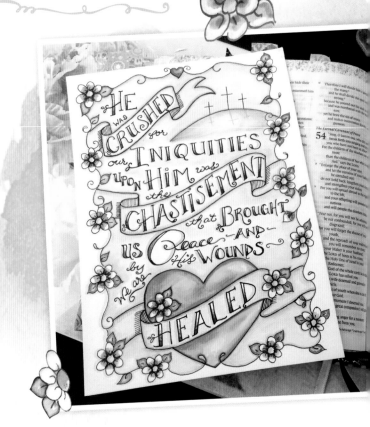

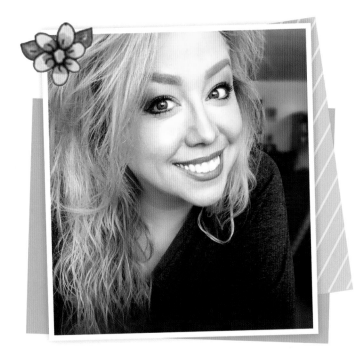

Jennifer lives in sunny Los Angeles, California, where she spends plenty of time at the beach and Disneyland with her husband and son.

Jennifer decided to re-create her mother's uplifting and supportive environment in her own home through Bible journaling. She began to draw and color in the new Crossway ESV Bible that her husband gave her for Christmas ("I told him it was the only thing I wanted!" she laughs). She was not without some reservations at first, feeling very nervous about making mistakes in her Bible in non-erasable ink.

"I WILL NEVER UNDERESTIMATE THE POWER OF HIS WORD."

But she powered through her fears, and nowadays, she doesn't sweat it if she makes errors. "Imperfection is on every one of my pages," she says. "At first it really troubled me, but I've since learned to accept it as something that is beautiful, too."

Getting started in Bible journaling gave Jennifer the confidence to reach out to the growing online

JEREMIAH 21:2

there is ... in my HEART AS IT WERE A BURNING FIRE SHUT UP IN MY BONES I AM WEARY WITH HOLDING IT IN — and ...

my mind— 6 therefore,
all no more be called
aughter. 7 And in this
ll cause their people
who seek their life.
to the beasts of the
eryone who passes
I will make them
at the flesh of his
s and those who

with you, 11 and
ple and this city,
ury in Topheth
re, declares the
s of Jerusalem
fferings have
oured out to

o prophesy,
"Thus says
d upon all
e stiffened

e house
ur beat
in Gate
m the
Terror
f and
And
tive
the
gs
nd
ro

there is in my heart as it were a burning fire
shut up in my bones,
nd I am weary with holding it in,
and I cannot.
For I hear many whispering.
Terror is on every side!
Denounce him! Let us denounce him!"
so all my close friends,
watching for my fall.
Perhaps he will be deceived:
then we can overcome him
and take our revenge on him."
But the LORD is with me as a dread warrior;
therefore my persecutors will stumble;
they will not overcome me.
They will be greatly shamed.
for they will not succeed.
Their eternal dishonor
will never be forgotten.
O LORD of hosts, who tests the righteous,
who sees the heart and the mind,
let me see your vengeance upon them,
for to you have I committed my cause.

Sing to the LORD;
praise the LORD!
For he has delivered the life of the needy
from the hand of evildoers.

Cursed be the day
on which I was born!
The day when my mother bore me,
let it not be blessed!
Cursed be the man who brought the news to my father,
"A son is born to you,"
making him very glad.
Let that man be like the cities
that the LORD overthrew without pity;
let him hear a cry in the morning
and an alarm at noon,
because he did not kill me in the womb;
so my mother would have been my grave,
and her womb forever great.
Why did I come out from the womb
to see toil and sorrow,
and spend my days in shame?

Will Fall to Nebuchadnezzar

is the word that came to Jeremiah from the LORD, when King Zedekiah
to him Pashhur the son of Malchiah and Zephaniah the priest, the son of
spring. 2"Inquire of the LORD for us, for Nebuchadnezzar² king of Babylon
against us. Perhaps the LORD will deal with us according to all his
ds and will make him withdraw from us."

Nebuchadrezzar, an alternate spelling of Nebuchadnezzar (king of Babylon) occurring frequently from
pelling is used throughout Jeremiah for consistency

Joel
Lamentations
Amos
Ezeki
John

community of Bible journalers and connect with others who shared her passion. She continues to reach deeper into herself in order to find an inner peace all her own. "I have grown more than I ever expected," she says. Bible journaling has had a concrete, undeniable impact on Jennifer's wellbeing. About a year ago, she encountered a passage that became a gateway to deep healing for her. "I had been seeking God for healing and restoration from hurts in my past. You know, the hurts that run so deep that you can't imagine ever being free from them? I was abused by a neighbor when I was just a little girl. The trauma of this was something I never thought I would be free from. It was like a dark cloud that followed me and colored my entire life. It had such a hold on me. I hid this wound from everyone who loved and knew me, but inside I was continually fighting a crippling fear and shame." When Jennifer came across 2 Kings 20:5, though, the passage spoke to her; she felt God's peace and love, and she knew that God was going to set her free: "I have heard your prayer, I have seen your tears; behold, I *will* heal you" (emphasis added). Jennifer often revisits that journaled page to remind herself of God's promise and that the dark experience of her childhood no longer has a hold on her. "His Word is alive and I am free! I will never underestimate the power of His Word ever again," she says.

As personal as Bible journaling is, Jennifer has found an irreplaceable joy in creating art within a supportive community of others who hear and respond to the same calling all over the world. She can always turn to her online network of Bible journalers to gather ideas and energy that help her flourish. "Social media has been such a blessing! There is an amazing online community on Instagram. I love opening up my feed and seeing all the inspiration of others who Bible journal as well," she says.

Jennifer has now built a thriving small business around her faith art, which she calls "Our Grateful Hearts," and she continues on her walk in faith in part by Bible journaling several times a week. She'll choose a verse or let a verse choose her, inspired by her pastor's sermon or her Bible study. "I feel like I'm expressing my love for my heavenly Father when I journal in my Bible," she says. "The art I create is a form of worship and it draws me closer to Him."

To see more from Jennifer, go to her website, www.ourgratefulhearts.com, or follow her on Instagram at @our_grateful_hearts. She's also on Facebook and Twitter!

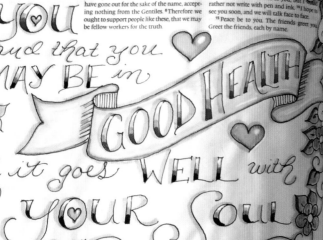

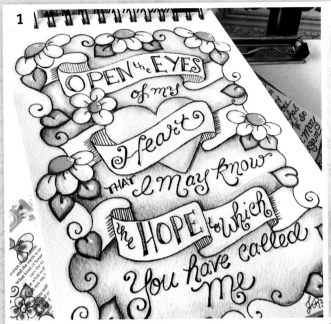

1

2

1. "I have two journaling Bibles, but a lot of times I've already journaled on the page with the scripture I am focusing on, so I will go ahead and do the verse outside of my Bible," says Jennifer. In response to the many requests she received for prints of her scripture art, Jennifer created this and other watercolor paintings, which can be found at www.ourgratefulhearts.com.

2. This set of images shows one of Jennifer's first entries and the Bible journaling process! Her favorite supplies are the GraphGear 1000 pencil to sketch, Micron pens to ink, and Tim Holtz Distress markers to add beautiful, vibrant color.

3. Banners, flowers, and flourishes define the signature style of Jennifer's Bible journaling. "I love banners because they add movement, are pleasing to the eye, and allow me to emphasize certain words," she shares. She loves to use flowers to frame the scripture lettering.

4. In this early Bible journaling entry, Jennifer felt called to create a relatively detailed drawing of the girl, using Prismacolor pencils and Micron pens.

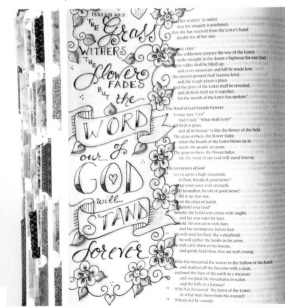

3

4

Rebekah R Jones

ONE MIRACLE LEADS TO ANOTHER

Not everyone has a miraculous life story, but some people, like Rebekah R Jones, definitely do. Beginning when she was twelve years old, Rebekah's physical health slowly but steadily and inexplicably declined, stumping doctor after doctor. By the time she was a young married woman, she was bedridden with no avenues left to her—save one. "I was slowly dying and, truly, God was my only hope. As I laid in bed for two and a half very scary and miserable years, I determined to focus on what God was doing in my life and let Him be larger than any problems I faced," says Rebekah. Simply put, she placed her faith in God.

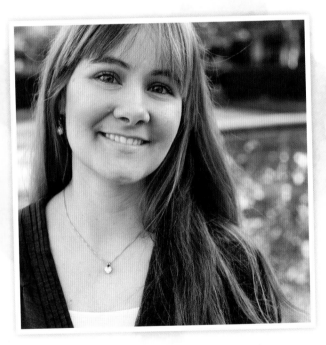

As a mixed-media artist, Rebekah runs a full-time art ministry from her colorful studio and cherishes time with close friends and family.

One day, her husband decided to take them to a Christian conference, where the speaker prayed for her recovery. "I felt what I can only describe as the physical power of God drop on me," says Rebekah. "I went home feeling miserable and woke up the next morning dramatically healed!" The doctors, though mystified, gave her a clean bill of health, and it was a completely fresh start for Rebekah.

Rebekah wanted to help others also encounter Jesus. While growing up she was taught by her very creative mom and grandma who both loved God deeply, and as a young adult had practiced faith journaling outside of the Bible. Now, after her miraculous recovery, she wanted to help people

"MY PASSION IS HELPING OTHERS ENCOUNTER JESUS THROUGH CREATIVITY."

fall more in love with Jesus by teaching creative devotionals. "It took some months to prepare my studio, and the very same week everything was set up, I was introduced to Bible journaling. God's timing is perfect! I knew I'd found what God had prepared me spiritually and practically for," she says.

build him a sure house, and he shall go in and out before my anointed forever. ³⁶And everyone who is left in your house shall come to implore him for a piece of silver or a loaf of bread and shall say, "Please put me in one of the priests' places, that I may eat a morsel of bread."'"

The LORD Calls Samuel

3 Now the boy Samuel was ministering to the LORD in the presence of Eli. And the word of the LORD was rare in those days; there was no frequent vision.

²At that time Eli, whose eyesight had begun to grow dim so that he could not see, was lying down in his own place. ³The lamp of God had not yet gone out, and Samuel was lying down in the temple of the LORD, where the ark of God was.

⁴Then the LORD called Samuel, and he said, "Here I am!" ⁵and ran to Eli and said, "Here I am, for you called me." But he said, "I did not call; lie down again." So he went and lay down.

⁶And the LORD called again, "Samuel!" and Samuel arose and went to Eli and said, "Here I am, for you called me." But he said, "I did not call, my son; lie down again." ⁷Now Samuel did not yet know the LORD, and the word of the LORD had not yet been revealed to him.

⁸And the LORD called Samuel again the third time. And he arose and went to Eli and said, "Here I am, for you called me." Then Eli perceived that the LORD was calling the boy. ⁹Therefore Eli said to Samuel, "Go, lie down, and if he calls you, you shall say, 'Speak, LORD, for your servant hears.'" So Samuel went and lay down in his place.

¹⁰And the LORD came and stood, calling as at other times, "Samuel! Samuel!" And Samuel said, "Speak, for your servant hears." ¹¹Then the LORD said to Samuel, "Behold, I am about to do a thing in Israel at which the two ears of everyone who hears it will tingle. ¹²On that day I will fulfill against Eli all that I have spoken concerning his house, from beginning to end. ¹³And I declare to him that I am about to punish his house forever, for the iniquity that he knew, because his sons were blaspheming God,¹ and he did not restrain them. ¹⁴Therefore I swear to the house of Eli that the iniquity of Eli's house shall not be atoned for by sacrifice or offering forever."

¹⁵Samuel lay until morning; then he opened the doors of the house of the LORD. And Samuel was afraid to tell the vision to Eli. ¹⁶But Eli called Samuel and said, "Samuel, my son." And he said, "Here I am." ¹⁷And Eli said, "What was it that he told you? Do not hide it from me. May God do so to you and more also if you hide anything from me of all that he told you." ¹⁸So Samuel told him everything and hid nothing from him. And he said, "It is the LORD. Let him do what seems good to him."

¹⁹And Samuel grew, and the LORD was with him and let none of his words fall to the ground. ²⁰And all Israel from Dan to Beersheba knew that Samuel was established as a prophet of the LORD. ²¹And the LORD appeared again at Shiloh, for the LORD revealed himself to Samuel at Shiloh by the word of the LORD.

The Philistines Capture the Ark

4 And the word of Samuel came to all Israel.
Now Israel went out to battle against the Philistines. They encamped at Ebenezer, and the Philistines encamped at Aphek. ²The Philistines drew up in line against Israel, and when the battle spread, Israel was defeated before the Philistines, who killed about four thousand men on the field of battle. ³And when the people came to the camp, the elders of Israel said, "Why has the LORD defeated us today before the Philistines? Let us bring the ark of the covenant of the LORD here from Shiloh, that it² may come among us and save us from the power of our enemies." So the people sent to Shiloh and brought from there the ark of the covenant of the LORD of hosts, who is enthroned on the cherubim. And the two sons of Eli, Hophni and Phinehas, were there with the ark of the covenant of God.

¹Or blaspheming for themselves ²Or he

Now, every year when the anniversary of her miraculous healing comes around, Rebekah celebrates by creating a Bible journaling entry that focuses on God's healing power. "I get to teach Bible journaling because I am no longer lying in bed, watching my life slip away. Because He restored my health, I've been able to pursue my passion of helping others encounter Jesus through creativity," she says.

Rebekah now runs her full-time art ministry through her blog, YouTube channel, and other social media, helping connect Bible journalers all over the world, and teaches through her online courses. She has had thousands of students so far. "I balance my time between creating entries on the pages of my Bible, supporting my wonderful community, and testing techniques and products to help Bible journaling be easy and stress-free," says Rebekah.

One technique she is very excited about is one she created herself, with beginners in mind, called page prep (which is explained on page 28). When Rebekah started teaching Bible journaling, she encountered many beginners who were frustrated and upset by the bleed-through they were experiencing on their thin Bible pages. This feedback led her to develop the page prep process, which creates a clear protective layer on top of the Bible page to prevent bleed-through during creativity. "My pages are still flat and smooth. . . . I can simply relax and enjoy the process, and everything stays right where I want it to!" she says.

Rebekah's idea for page prep was a natural development from her years of experience in creativity and her use of mixed media in Bibles. She believes it's important to create without worry, and her hope is that budding artists can learn to relax and enjoy the process of making art in a way that helps them be transformed by the Word of God. "People often struggle with a fear of hurting their Bible, or of not pleasing God if they create on its pages. As a result, they are timid in their process," says Rebekah. "My advice is to see Bible journaling as a way to connect with God, not a way to perform for Him. Dedicate a Bible to spending time creatively with God. See it as a working book that serves your time with God and helps you memorize scripture and encounter Him in its pages."

For more information on her online courses, creative devotionals, and other helpful Bible journaling teaching, check out Rebekah's website, *www.RebekahRJones.com*; you can also follow her on Instagram at @rebekahrjones.

Rebekah focused on Psalm 98:4–6 for this entry. She shares, "Positioning our heart in praise to God, no matter our circumstances, can bring about beautiful things and a richness to our friendship with Him."

1

2

1. Rebekah taught from Joshua 1:9 for her first creative devotional/tutorial, encouraging others to be brave along with her using transparent color.

2. In Rebekah's Bible Art Journaling Challenge, she teaches how to personalize a Bible cover and its page edges. Rebekah says, "Without even opening this Bible, it reminds me that 'the Word became flesh and dwelt among us' (John 1:14)."

3. This layout, inspired by Psalm 42:7, was created with Inktense pencils and Faber-Castell Pitt Brush Pens. "Their vibrant color brought home what I was trying to capture about the breakthrough God has for us, in the midst of any storms of life crashing around us," Rebekah says.

4. Rebekah spent 12 hours coloring this page with watercolor pencils and colored pencils. "Leaves were falling and I wanted to hold a reminder of how quickly seasons change," she shares. "By the time I emerged from it, I'd been transformed by pondering the depth of its meaning in my life."

5. Rebekah reflected on the importance of setting our hope on God for this piece as she scraped on some acrylic paint, stenciled a moon and stars, and finished by stamping a sentiment. She reiterates, "God is good and we can hang our hope on Him!"

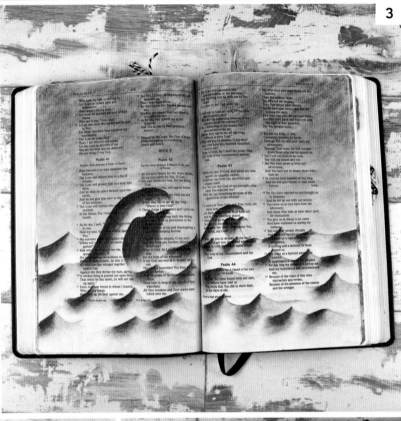

3

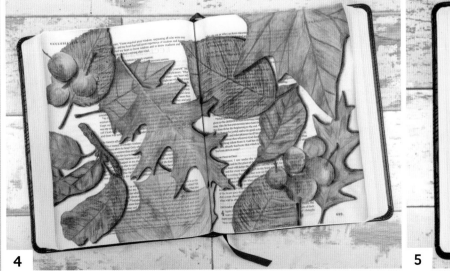

4

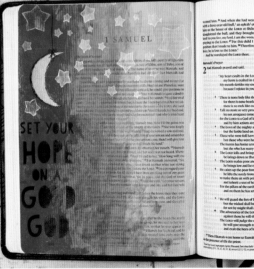

5

Christina Lowery

MAKING TIME FOR GOD THROUGH BIBLE JOURNALING

Christina Lowery has been creatively connecting herself to God's Word for more than twenty years through writing and doodling. "I don't consider myself an artist, but I have been a creative person for as long as I remember," she says. So when she discovered Bible journaling at the end of 2015, it wasn't a stretch for her to branch out a bit from what she was used to.

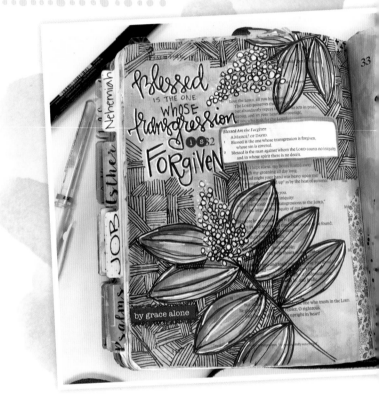

Christina, her husband, and her four children live in rural southern Georgia where they enjoy spending time with family and serving through the local church.

Bible journaling has helped Christina to refocus her energies in her time spent with God and, indeed, to spend more time with Him, period. She refers to Psalm 1 to help explain how this has been true: "Blessed is the man... [whose] delight is in the Law of the Lord, and on it he meditates day and night." Christina says, "Meditation on God's Word is something that is so easy to overlook in our busy schedules, and I've often been guilty of completing daily reading just to check it off my list. Bible journaling forces me to slow down and internalize God's Word, not just check it off a to-do list."

For Christina, the process of painting and journaling allows her to spend time meditating on scripture, and the artistic aspect of this process helps her to internalize it. "Knowing that the Word is living and active, I like to give myself time to soak in it and apply it to my life," she says. "I often paint more elaborate pictures to give myself an hour or so for the Spirit to guide my heart in Truth." Christina has found that spending this time with God's Word helps her remember specific verses more easily.

"SLOW DOWN AND INTERNALIZE GOD'S WORD."

She also records scripture in separate notebooks every morning, which is an additional way to memorize passages and concepts.

To those who are unfamiliar with Bible journaling or are still a bit dubious about its intent, Christina offers this perspective: "I know that when you look at pages

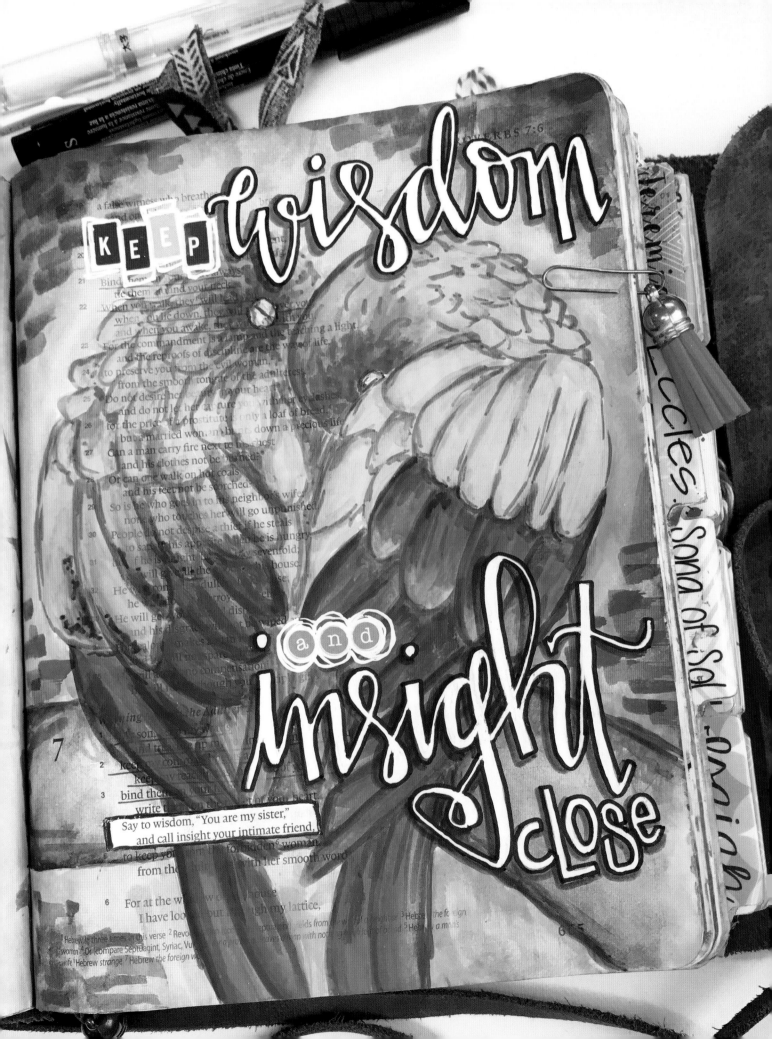

filled with flowers and scripture, the flowers may seem unimportant, and even superfluous, but the time spent doodling is, for me, a very focused time to memorize portions of scripture. As with most things, the time spent is what you make of it."

When deciding what to illustrate in her Bible, Christina says she mainly follows her yearly Bible reading plan and illustrates as God leads her. "I just read, and when God brings an image or thought to mind, I make a mental note and then come back to it once I've completed my reading," she says.

> ## "TIME SPENT DOODLING IS A VERY FOCUSED TIME TO MEMORIZE SCRIPTURE."

She doesn't follow a detailed artistic process; rather, she typically jumps in with watercolors to paint whatever image God brought to her mind. Then, when the painting is done, she letters on top of the color. "[As] I'm writing the Word, I focus on saying it to myself over and over as I copy it, writing it on my heart," she says. Christina doesn't have any concerns about the fact that she covers entire pages of her Bible with art, because she has many other copies of the Bible that she uses for concentrated reading and study. "At the end of the year, every word will have been read, and almost every page will be painted or journaled in some way or another," she says.

Christina is happy to share her love of Bible journaling with others both online and in her community. She brings her journaling Bible to church and many other places, and loves answering the frequent questions she gets about it. Her advice to those just starting their own Bible journaling journey is to connect with God and His Word in a way that is comfortable for them. "Start simple and make a daily commitment," she says. "Branch out as you feel led, and don't be concerned with your expression looking like anyone else's. Keep the Lord as your focus!"

To get inspired by more of Christina's work, follow her on Instagram at @christinasalive and visit her on Facebook.

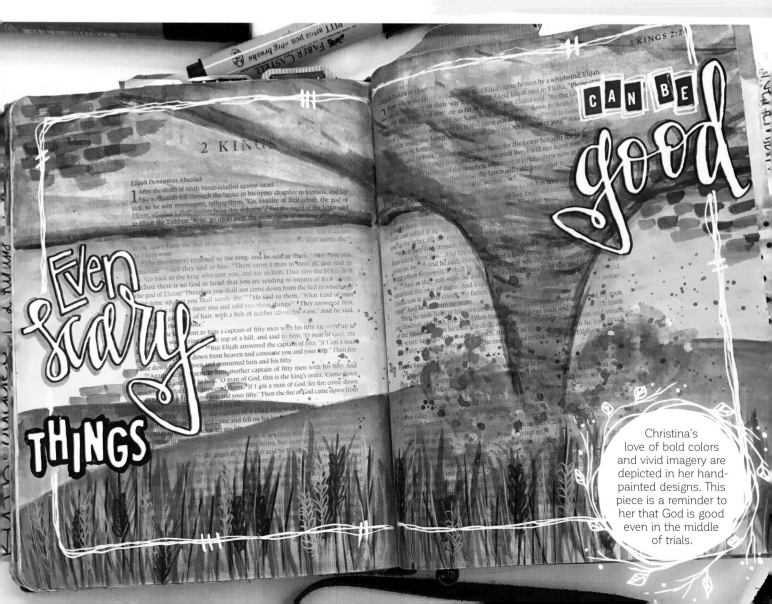

Christina's love of bold colors and vivid imagery are depicted in her hand-painted designs. This piece is a reminder to her that God is good even in the middle of trials.

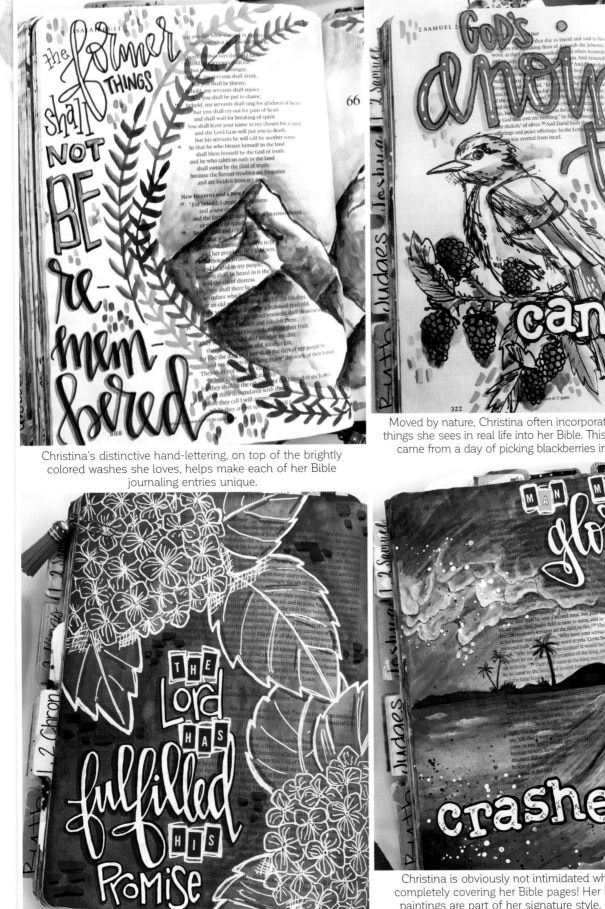

Christina's distinctive hand-lettering, on top of the brightly colored washes she loves, helps make each of her Bible journaling entries unique.

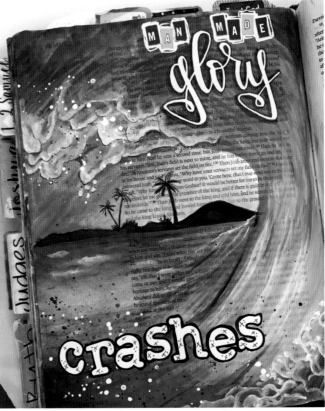

Moved by nature, Christina often incorporates images from things she sees in real life into her Bible. This particular image came from a day of picking blackberries in her backyard.

About another piece inspired by her own backyard, Christina passionately says, "I ADORE HYDRANGEAS!"

Christina is obviously not intimidated when it comes to completely covering her Bible pages! Her bright watercolor paintings are part of her signature style. "I'm a seasonal painter. So when it's summertime, beach scenes run rampant... And did I mention that I love color?"

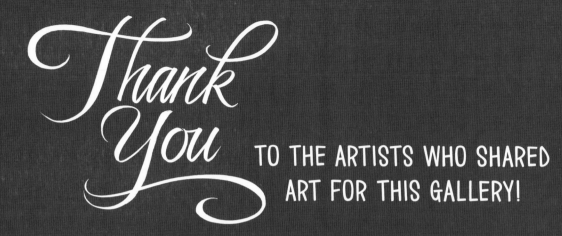

Thank You

TO THE ARTISTS WHO SHARED ART FOR THIS GALLERY!

Kari Ashauer	Sue Kemnitz
Lisa Baird	Jennifer Lynn Kniskern
Hannah Ballesteros	Anneke Korfker
Monica Bauer	Martha Lever
Gail Beck	Penny Lisk
Eva Blaszczyk	Karina Litvinov
Yvette Bowling	Pat Maier
Bridgett Brainard	Lisa McPeak
Terri Brown	Kathy Milici
Sue Carroll	Holly Monroe
Jennifer Casey	Tricia Moore
Debbie Cole	Tracey Lyon Nicholson
Michelle Craig	Tammy Null
Tess Crawford	Beth Nyhart
Connie Denninger	Lisa Peterson
Susan Elizabeth	Milagros Rivera
Christy Fae	Heather Slaton
Rut Faur	Victoria Southard
Mary Anne Fellows	Jade Stewart
Becky Griggs	Grace Veenker
Heidi Guenther	Lori Vliegen
Rachelle Hartman	Andrea Wood
Jill Suzanne Hatcher	Regina Yoder
Karen Hunter	Kristen Zeitler

GALLERY

THEMES

This section is designed to showcase some of the wonderful pieces we discovered as we began our search for Bible journaling art. You'll find unique and unusual pieces of art from people who journal both inside and outside of the Bible. You'll also find many illustrative styles in this section, such as three-dimensional work, photographic journaling, illustration, patterning, graphic floral art, and more. Please use this collection as a springboard for your own creativity to find new ideas for making God's Word shine through your own work.

OUTSIDE THE BIBLE

Journaling outside the Bible encompasses everything from wall writing to painting on fabric to scrapbooking and art journaling. The two artists featured on this spread, Jennifer Casey and Sue Kemnitz, are known for journaling about faith in creative ways.

Jennifer Casey pairs her beautiful photography with scripture verses throughout her personal journal.

Wooden charm with die-cut heart, watercolors, pen and ink, labels, original photo.

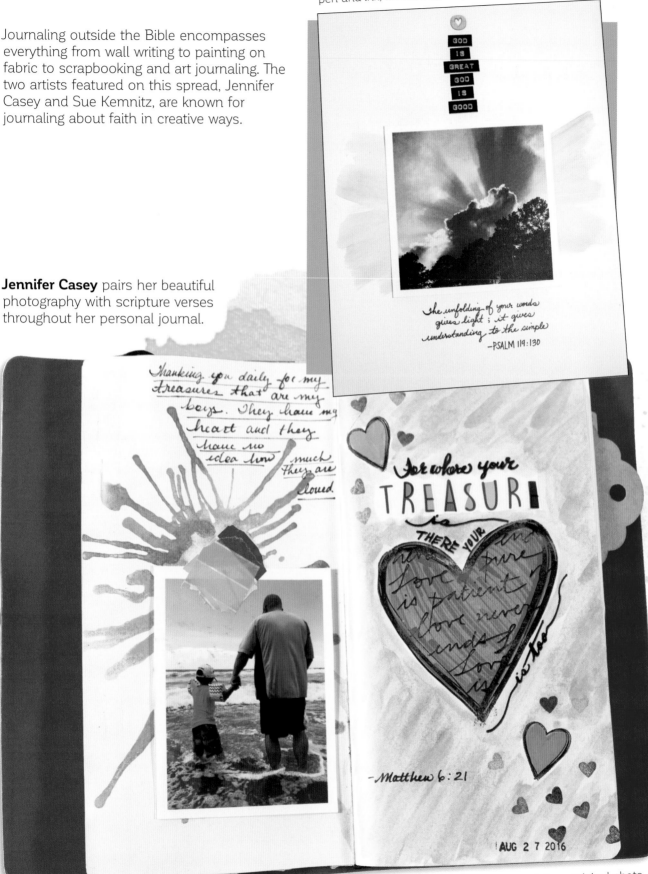

Watercolors, pen and ink, stamps, stickers, original photo.

Sue Kemnitz is a mixed-media artist and teacher who uses art journaling as a way to express her faith.

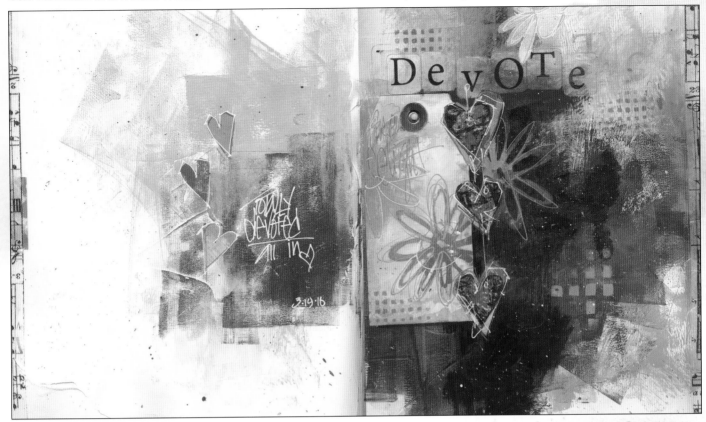

Acrylic paints, stencils, markers, tag, washi tape.

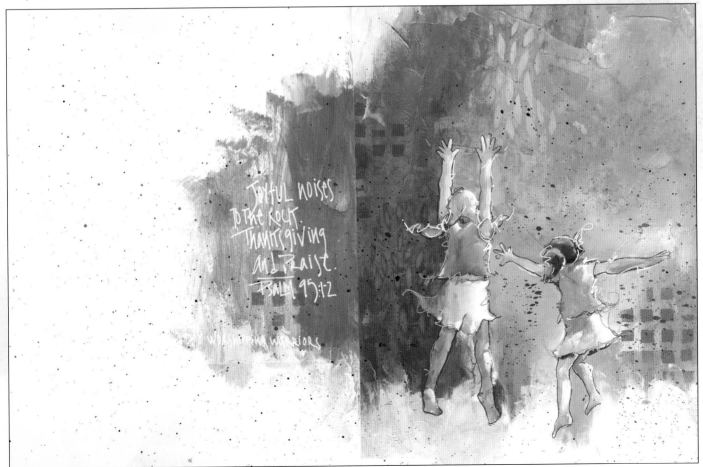

Acrylic paints, stencils, markers, pen.

OUTSIDE THE BIBLE

Third-generation calligrapher **Holly Monroe** has a gift for inspiring others by bringing God's Word to life with flourishes, florals, illustrations, and colorful hand lettering. Her mission is "to feed the soul by making meaningful words beautiful." Holly's elegant work is created outside the Bible, mostly by commission, and she recently started working on a larger scale, lettering scripture on the walls of churches. Each of the two wall-writing projects shown here took about a month: two weeks to design in her studio and two weeks to execute at the church. Both are finished with interior wall paint and incorporate 23 karat gold leaf.

The "O Magnify" piece was designed first in pencil on a 6" by 20" sheet and digitally enlarged onto a 36"-wide roll of white paper. The final design, at the Evangelical Community Church in Cincinnati, OH, is about 10' off the ground and approximately 3' by 10'.

The "Romans 12" project, commissioned by Northminster Presbyterian Church in Cincinnati, OH, is 15' off the ground and stretches along two 14" by 50' soffits. Holly highlighted the ten decorated letters with 24 karat gold.

For this "Love and Serve" benediction, Holly created an impactful gradient paste paper background. After sketching the lettering in pencil, Holly transferred it with white Saral paper and then lettered the piece in gouache. As a finishing touch, she gilded one line and applied 24 karat gold powder accents to highlight the large words.

"For I Know the Plans" was created simply with bands of watercolor and white ink to make the lettering pop.

"Lord Provider Jehovah Jirah" incorporates multiple lettering styles in multiple colors. It was lettered on tan paper. Pastel was added around the large letters for interest. Originally commissioned as a greeting card, it is now a suitable-for-framing reproduction available at Holly's online store, *www.hollymonroe.com*.

OUTSIDE THE BIBLE

Dangle houses, delicate lettering, and mixed-media fiber art are some of the many creative ways people choose to express their faith outside the pages of their Bible.

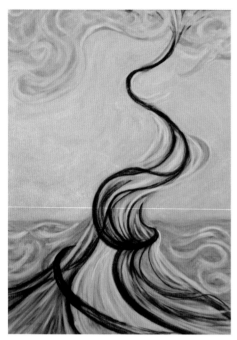

Penny Lisk, *Ascension*. Acrylic and charcoal on canvas.

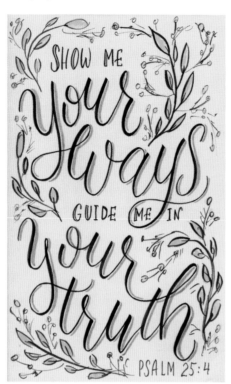

Karina Litvinov. Calligraphy pens, brush pens.

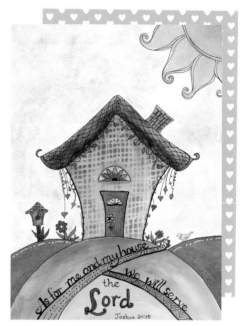

Mary Anne Fellows. Brush pens, pan pastels, gel pens, acrylic paint markers.

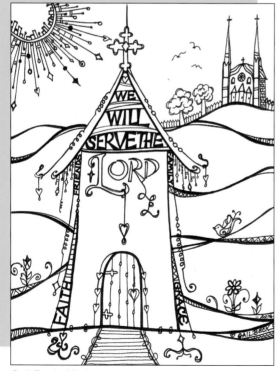

Gail Beck. Markers.

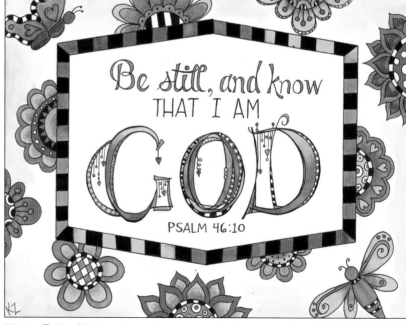

Kristen Zeitler. Watercolor markers, water brush, pen.

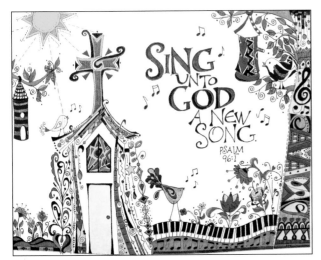

Becky Griggs. Markers, pen.

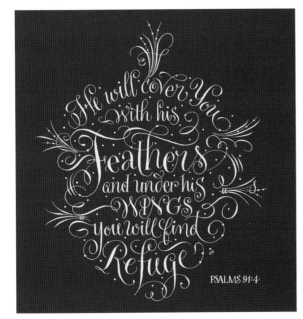

Kathy Milici. Pen and ink.

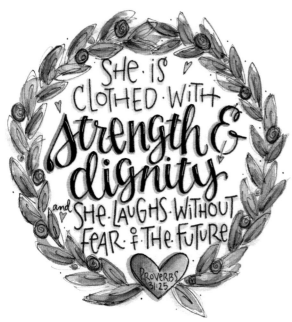

Lori Vliegen. Pen, brush pens, markers.

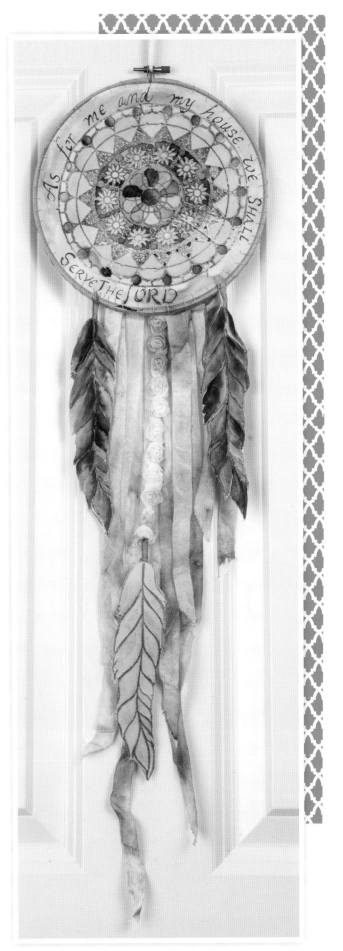

Milagros Rivera. Stencils, wood embroidery
hoop, ribbon, fabric, watercolors.

TRUST IN THE LORD (OUTSIDE THE BIBLE)

As we saw in the layout section (pages 46–51), you can create your own artistic interpretation of any text simply by emphasizing the words you find meaningful and arranging them—along with an illustration, if desired—in a visually pleasing manner on the page. This spread features five variations of Proverbs 3:5, all created by artists working outside the Bible. Pages 110–111 feature examples of the same scripture drawn and lettered inside the Bible. Study the variety of styles—from bold typographic treatments to whimsical animals to delicate illustrations—and use them as inspiration for your own interpretation of this verse.

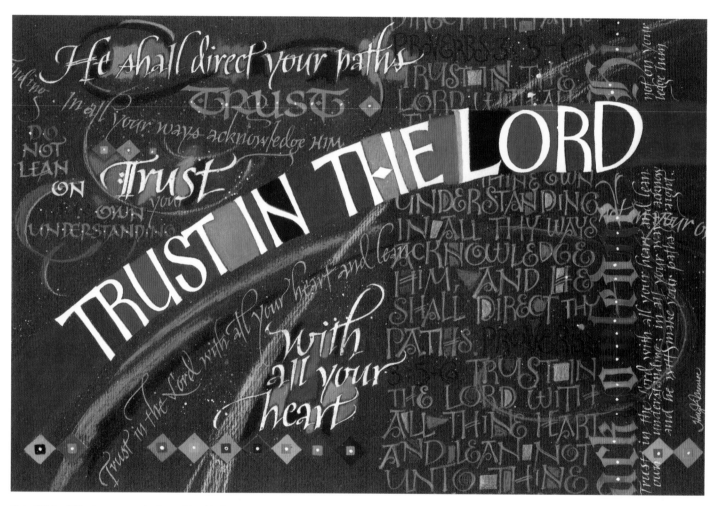

This 13" by 19" piece was designed by Holly Monroe for a Cincinnati entrepreneur who wants God to direct his path. It was created on dark green paper and lettered in a variety of different mediums. The main words jump to the foreground in white, the colored pencil lends a recessive quality, 24 karat gold adds highlights, and the pastels add warmth. Gouache, white ink, pastels, colored pencils, 24 karat gold powder.

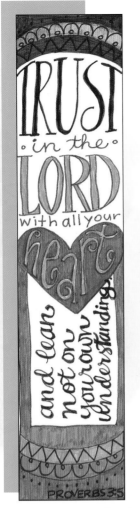

Tracey Lyon Nicholson. Pen, brush markers, highlighter.

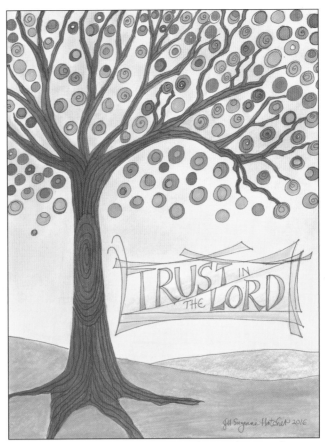

Jill Suzanne Hatcher. Permanent markers, gel pens, glitter markers, colored pencils, chalk pastels.

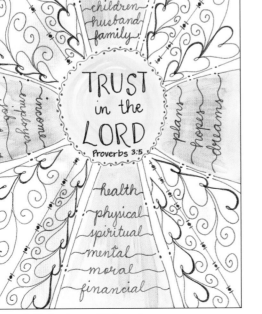

Hannah Ballesteros. Watercolors, pen.

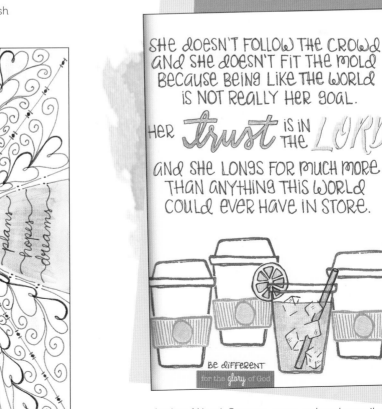

Andrea Wood. Stamps, pens, colored pencils, pigment inks, stickers.

TRUST IN THE LORD (INSIDE THE BIBLE)

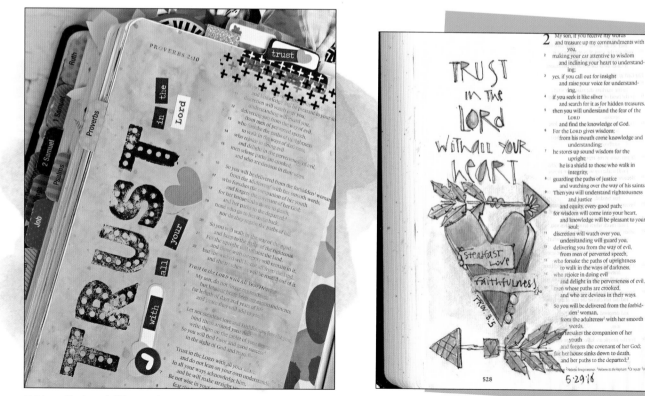

Christy Fae. Pen, gel pens, watercolors.

Bridgett Brainard. Watercolors, stamps, stickers, washi tape, word fetti.

Sue Kemnitz. Colored pencils, pens.

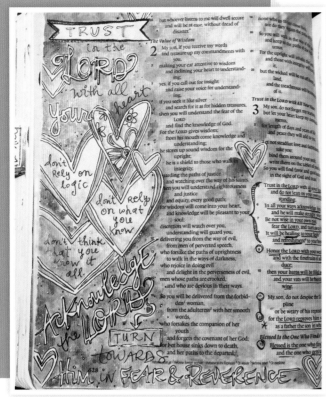

Heidi Guenther. Pen, gel pen, metallic gelatos, ink, wax pastels, water brush, stamp.

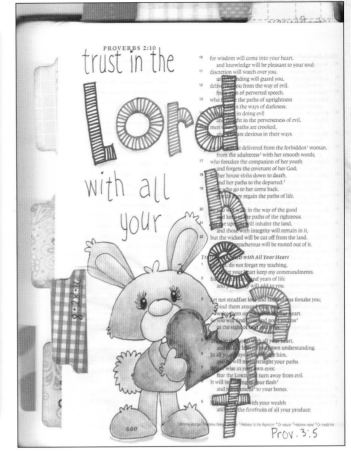

Tricia Moore. Pen, wax pastels, markers, gesso.

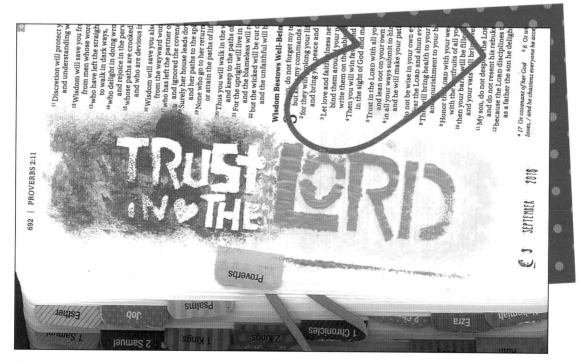

Michelle Craig. Embossing powder, pigment sticks, die cuts.

GRAPHIC

Tammy Null. Acrylic paint, stamps, washi tape, stickers, paper.

Tammy Null. Acrylic paint, stamps, washi tape, die cut.

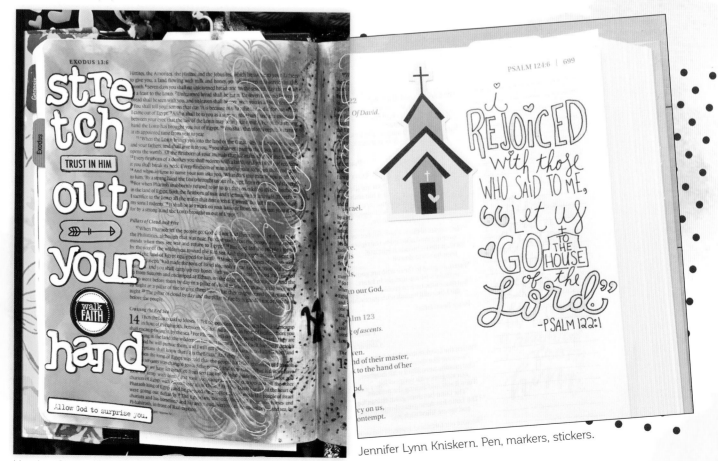

Heather Slaton. Stamps, ink, stickers.

Jennifer Lynn Kniskern. Pen, markers, stickers.

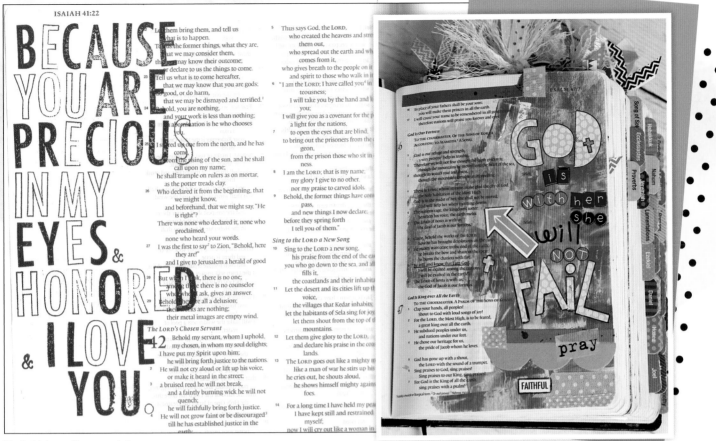

Beth Nyhart. Stamps, ink.

Bridgett Brainard. Stickers, washi tape, pen, acrylic paint.

Grace Veenker. Watercolors, pen.

Jennifer Casey. Washi tape, stickers, stamps.

PATTERNING

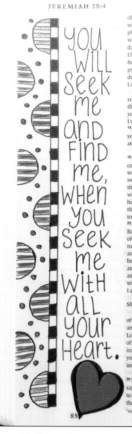

Lisa McPeak. Colored pencils, pen.

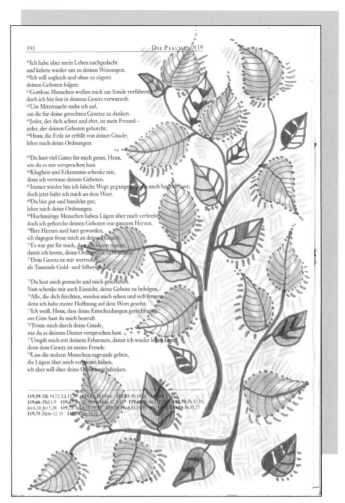

Eva Blaszczyk. Pens.

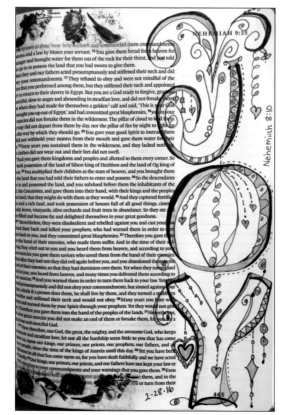

Connie Denninger. Colored pencils, pen, washi tape.

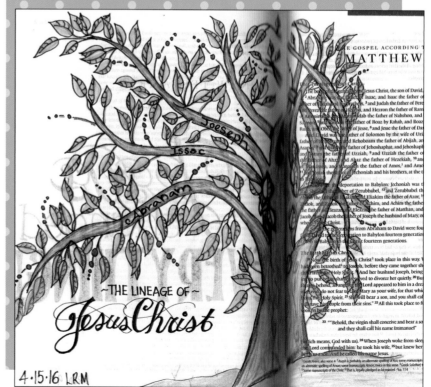

Lisa McPeak. Colored pencils, pen.

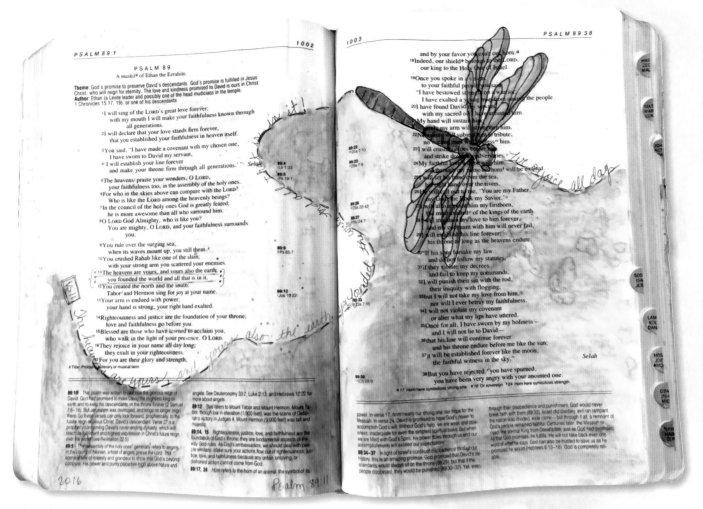

Lisa Peterson. Watercolors, colored pencils, ink, markers.

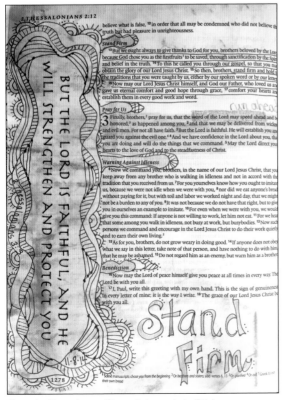

Connie Denninger. Pen, distress ink, Bible verse rub-on transfer.

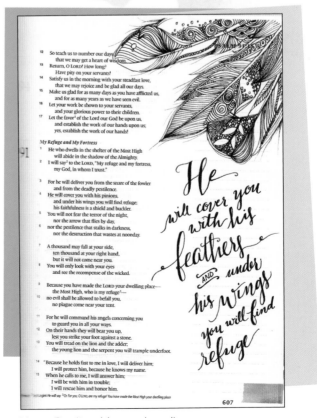

Yvette Bowling. Matte gel medium, pen.

WATERCOLOR EFFECTS

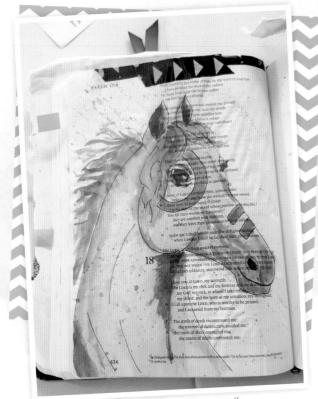

Victoria Southard. Pen, watercolor pencils.

Rut Faur. Vintage image, watercolor pencils, pen, pencil, glue, clear nail polish.

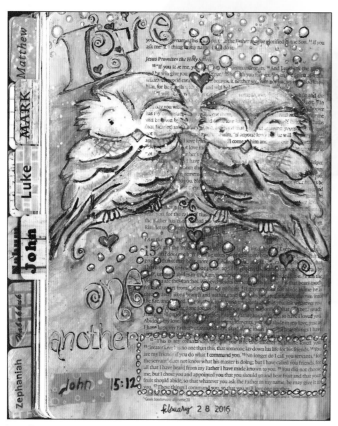

Lisa Baird. Watercolors, stamps, pen, gel pens, colored pencils.

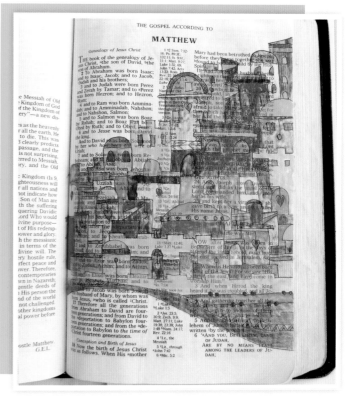

Susan Elizabeth. Watercolor pencils, pen.

COLORED PENCILS

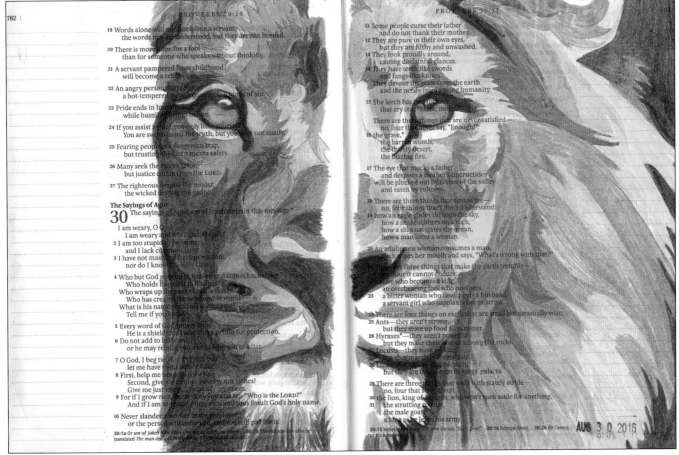

Jade Stewart. Colored pencils, blending pencil, transfer paper.

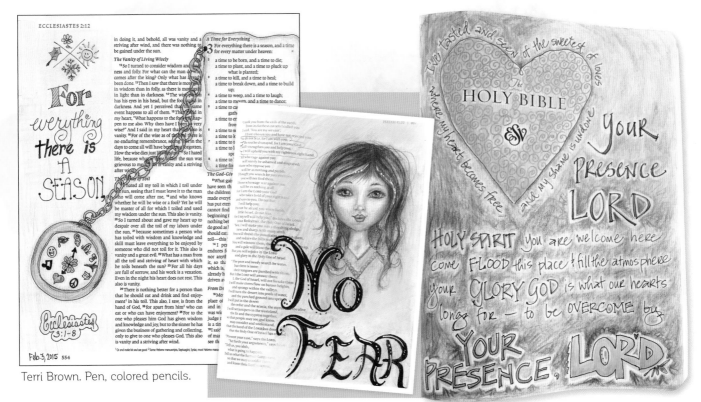

Terri Brown. Pen, colored pencils.

Debbie Cole. Pen, colored pencils, gel pens.

Pat Maier. Colored pencils, pen.

FLORAL

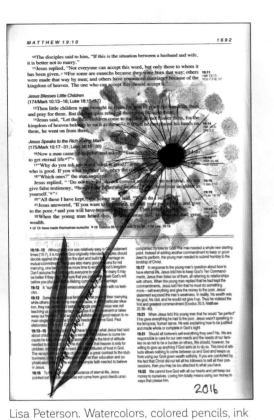

Lisa Peterson. Watercolors, colored pencils, ink (stamped thumbprints), markers.

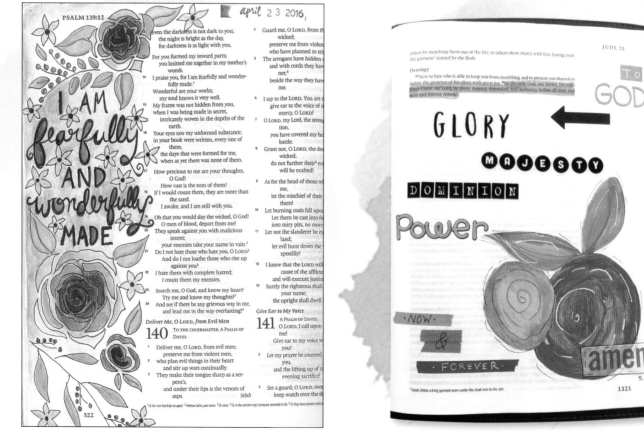

Jennifer Lynn Kniskern. Pen, markers, washi tape, stamps, dried flower.

Kari Ashauer. Pen, watercolors.

Regina Yoder. Stickers, washi tape, watercolors, pen.

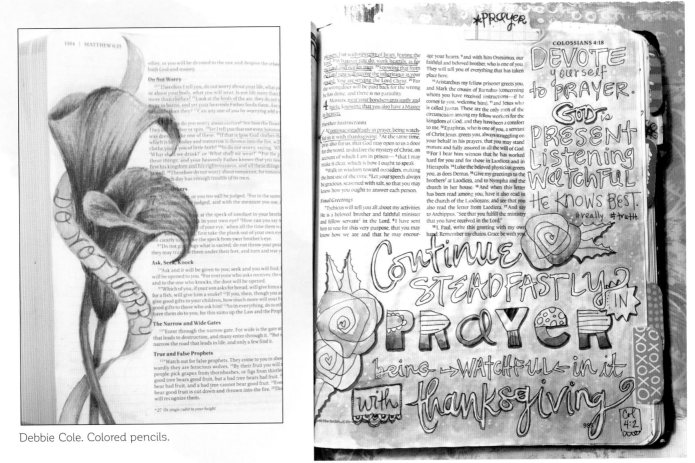

Debbie Cole. Colored pencils.

Heidi Guenther. Pen, wax pastels, gel pens, water brush, tabs.

Anneke Korfker. Gesso, pen, colored pencils, watercolors, glue, magazine clippings.

Yvette Bowling. Matte gel medium, watercolors, pen.

LINEWORK

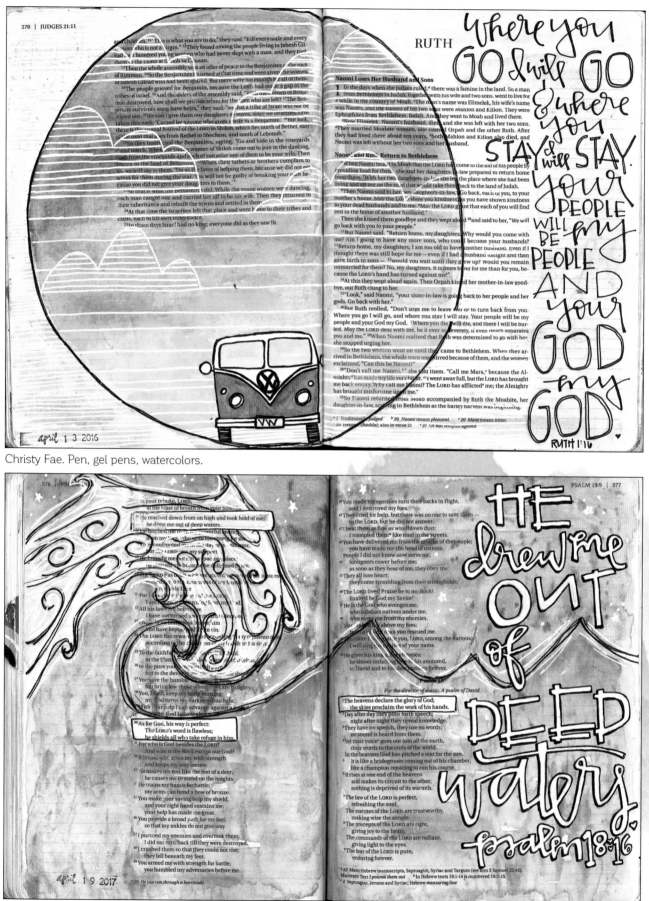

Christy Fae. Pen, gel pens, watercolors.

Christy Fae. Pen, gel pens, watercolors.

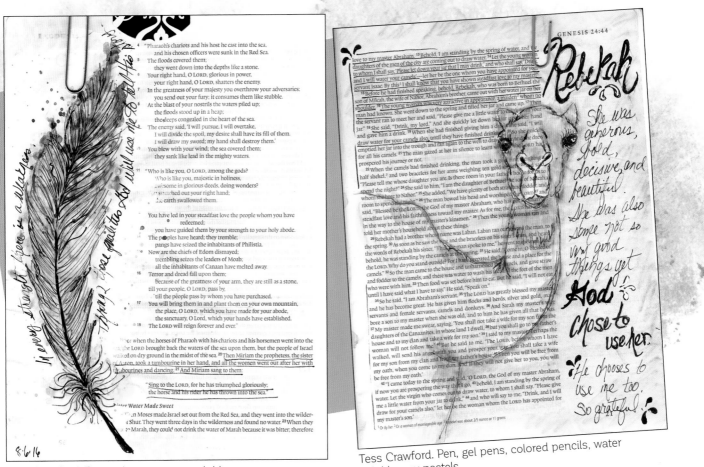

Tess Crawford. Pen, gel pens, water soluble wax pastels, acrylic paint.

Tess Crawford. Pen, gel pens, colored pencils, water soluble wax pastels.

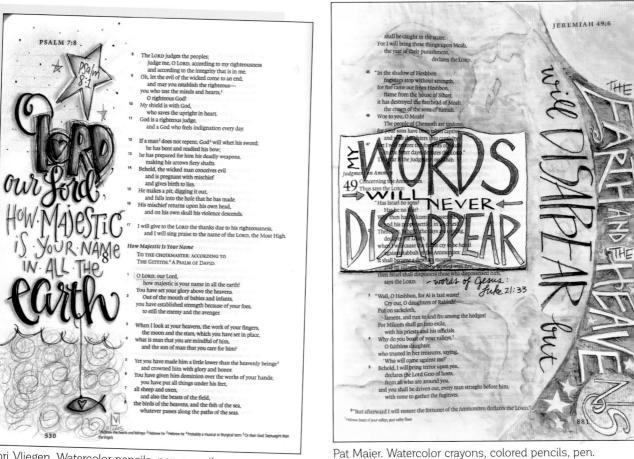

Lori Vliegen. Watercolor pencils, pen, pencil.

Pat Maier. Watercolor crayons, colored pencils, pen.

BRIGHTS

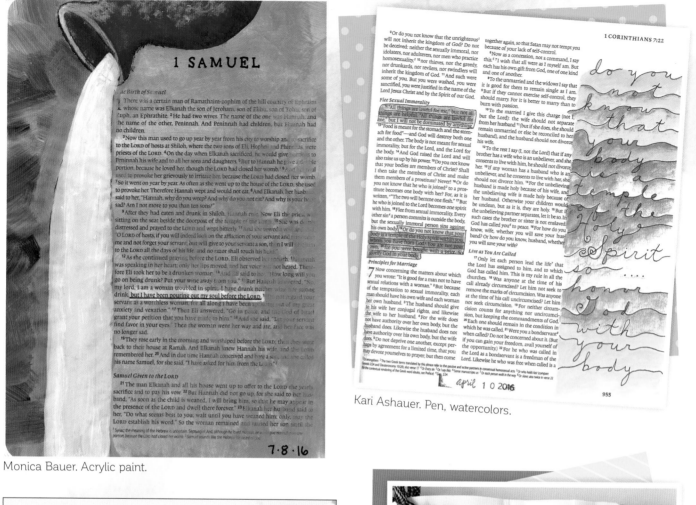

Monica Bauer. Acrylic paint.

Kari Ashauer. Pen, watercolors.

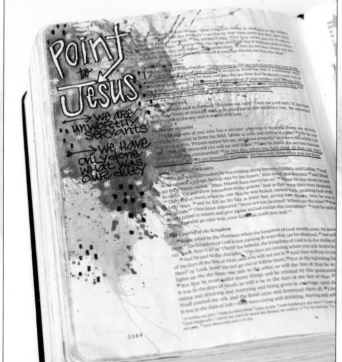

Karen Hunter. Acrylic paint, pen.

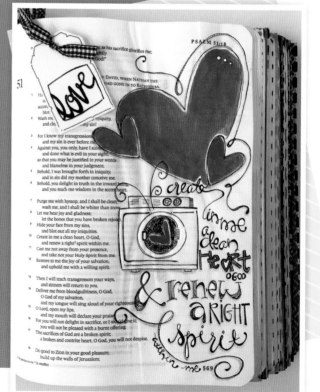

Sue Carroll. Watercolors, pen, die cut, ribbon.

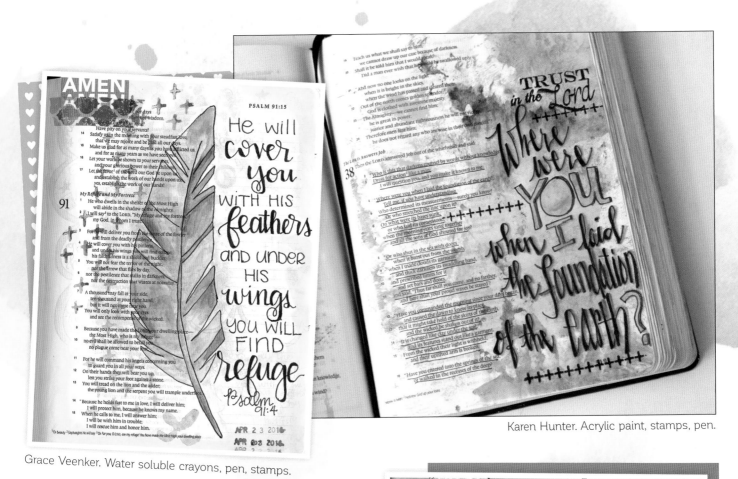

Grace Veenker. Water soluble crayons, pen, stamps.

Karen Hunter. Acrylic paint, stamps, pen.

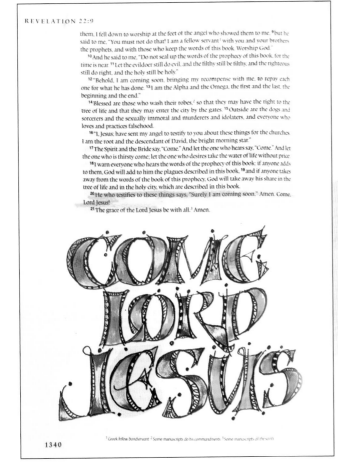

Martha Lever. Pen, brush pens.

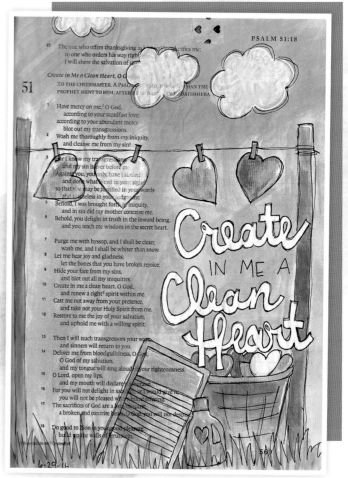

Rachelle Hartman. Watercolors, pen.

RESOURCES

WEB RESOURCES

www.biblejournalingjumpstart.com
www.biblegateway.com
www.littlefaithblog.weebly.com
www.janngray.com
www.rachelwojo.com
www.creative-bible-journaling.com
www.biblejournalingdigitally.com

ARTIST WEBSITES

Joanne Fink: www.calligraphers.com
Regina Yoder: www.reginayoder.com
Tai Bender: www.growingmeadows.com
Debbie Cole: www.debbiecole.com
Connie Denninger: www.constancedenninger.blogspot.com
Karla Dornacher: www.karladornacher.com
Krista Hamrick: www.kristahamrick.com
Karen Hunter: www.karenscraps.blogspot.com
Rebekah R Jones: www.rebekahrjones.com
Sue Kemnitz: www.suekemnitz.com
Penny Lisk: www.pennylisk.com
Holly Monroe: www.hollymonroe.com
Shanna Noel: www.illustratedfaith.com
Jennifer Rydin: www.ourgratefulhearts.com
Valerie Sjodin: www.valeriesjodin.com
Valerie Wieners-Massie: www.valeriewienersart.com

SOCIAL MEDIA

Social media offers amazing Bible journaling resources. You can connect with other Bible journaling artists, find inspiration—and spend hours—viewing styles and pages in different Bibles, and learn tools and techniques to help you on your creative faith journey. The three most popular social media sites for Bible journaling are Facebook, Pinterest, and Instagram.

FACEBOOK

There are many Facebook groups devoted to Bible journaling. Here are some suggestions to get you started:
Everyday Faith
(www.facebook.com/groups/1789668217950747)
Illustrated Faith/Bible Journaling Community
(www.facebook.com/groups/illustrateYOURfaith)
Bible Stories from the Heart
(www.facebook.com/groups/1447039392265675)

Bible Art Journaling Challenge
(www.facebook.com/groups/1562136987363764)
DC Metro Visual Faith Community
(www.facebook.com/groups/1021481294570736)
North Carolina Visual Faith Community
(www.facebook.com/groups/784988534940164)
So Cal Visual Faith Community
(www.facebook.com/groups/896071830475898)
Great Lakes Visual Faith Community
(www.facebook.com/groups/1132124493538251)
The Paradigm Exchange Bible Journaling Community
(www.facebook.com/groups/1788136191472737)

INSTAGRAM

If you are looking for Bible journaling inspiration, try searching for these hashtags (and using them yourself!): #biblejournaling, #bibleartjournaling, #bibleart, #biblejournalingjumpstart, #biblejournalingcommunity, #artworship
And check out the Instagram feeds from some of our contributors:
Joanne Fink: @zenspirations
Bridgett Brainard: @Bridgett.Brainard
Jennifer Casey: @ourdenstories
Tess Crawford: @ibumom
Heidi Guenther: @aglimpseofjoy
Karina Litvinov: @whispersindesign
Christina Lowery: @christinasalive
Shanna Noel: @shannanoel
Rebecca Rios: @ps348girl
Sephra Travers: @sephras_sketchbook
Lori Vliegen: @elviestudio

PINTEREST

Pinterest is a visual feast for the eyes! If you want inspiration on a particular verse, just type it in to the search bar. You'll be delighted with what you find! And check out these informative resources:
www.pinterest.com/rachelwojo/bible-journaling
www.pinterest.com/familychristian/bible-journaling
www.pinterest.com/biblelovenotes/bible-journals
www.pinterest.com/heartofwisdom/bible-journaling
www.pinterest.com/bible_journal
www.pinterest.com/creativebiblejo
www.pinterest.com/journalingdaily
www.pinterest.com/biblejournallov

MEETUP

Meetup is a great way to literally meet up with other people who share your interests. Go to www.meetup.com and search "Bible journaling." If there aren't any groups in your area, consider starting one!

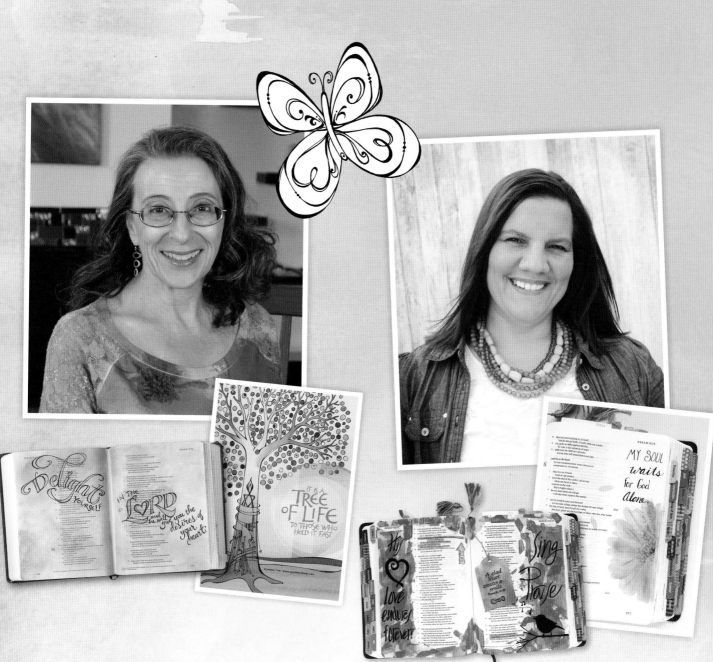

ABOUT THE AUTHORS

Joanne Fink is a designer, calligrapher, inspirational speaker, and author of the best-selling Zenspirations® book series. The second edition of her personal memoir, *When You Lose Someone You Love*, will be published by Fox Chapel in the fall of 2017. Joanne's YouTube videos have had more than a million views, and she loves to "inspire others to fly" through her seminars, workshops, licensed products, and weekly blog. Joanne lives with her two children in Central Florida, where she is on the board of the Modern Widows Club. For more information about Joanne, or to sign up for her weekly blog, visit *www.zenspirations.com*.

Regina Yoder is an inspiring women's ministry leader, inventor, wife, mother, and homeschooling instructor who is passionate about helping people experience a deeper level of intimacy with Christ through the art of Bible journaling. Gina has written and produced a Bible memory system, Clubhouse Kidz, in addition to designing, developing, and patenting a line of creative tools for scrapbooking and Bible journaling, both of which are available on her website, *www.reginayoder.com*. She lives with her husband and their eight children in central Illinois' Amish country, where the locals commonly recognize the family's 12-passenger "Yoder-Toter."

INDEX

Note: Page numbers in **bold** indicate artist profiles. Page numbers in *italics* indicate gallery artists/art.

Believe
IN MIRACLES

The following bonus section is chock-full of goodies—more than 150 designs on perforated thin stock pages, 270 full-color stickers, and 60 designs on translucent sheets of vellum—all of which can be used in a variety of ways. This deluxe assortment of tabs, traceable bookmarks, margin fillers, borders, icons, words, and stickers can be enjoyed by both beginners and seasoned artists alike.

The small icons in this section can be used as a reference. Draw them freehand larger or smaller, or trace them in their original size. They can even be cut out, colored, and adhered to a Bible page as embellishments. The black and white illustrations were intentionally chosen to be a starting point for adding elements such as color and/or patterning. The larger images can be cut out and attached to a page with washi tape to create added space for writing on the back, as shown on page 35.

The full-color border stickers can be used to cover the back of a page that has bled through or be added anywhere a quick accent of color is needed. Add the tab stickers to the first page of each book of the Bible for easy reference when looking for a specific verse. And there's plenty more—everything you might want in order to start this journey is available here. Mix and match as desired! We'd love to see what you create! Please share photos of your Bible journaling in the Facebook group "Everyday Faith" (listed in the resources section on page 124).

BONUS SECTION

Seek PRAY

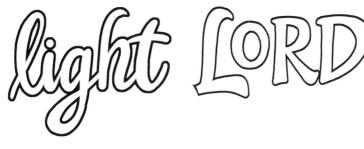

light LORD

hope HOPE

Bless Love

Create GOD

Believe

Grace

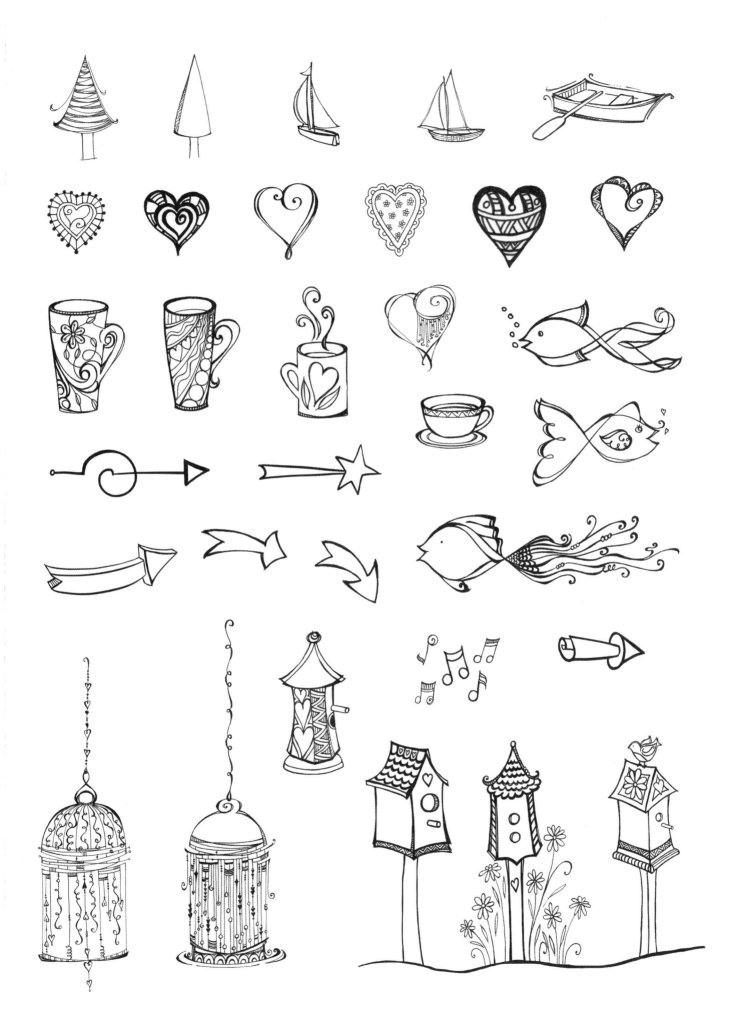

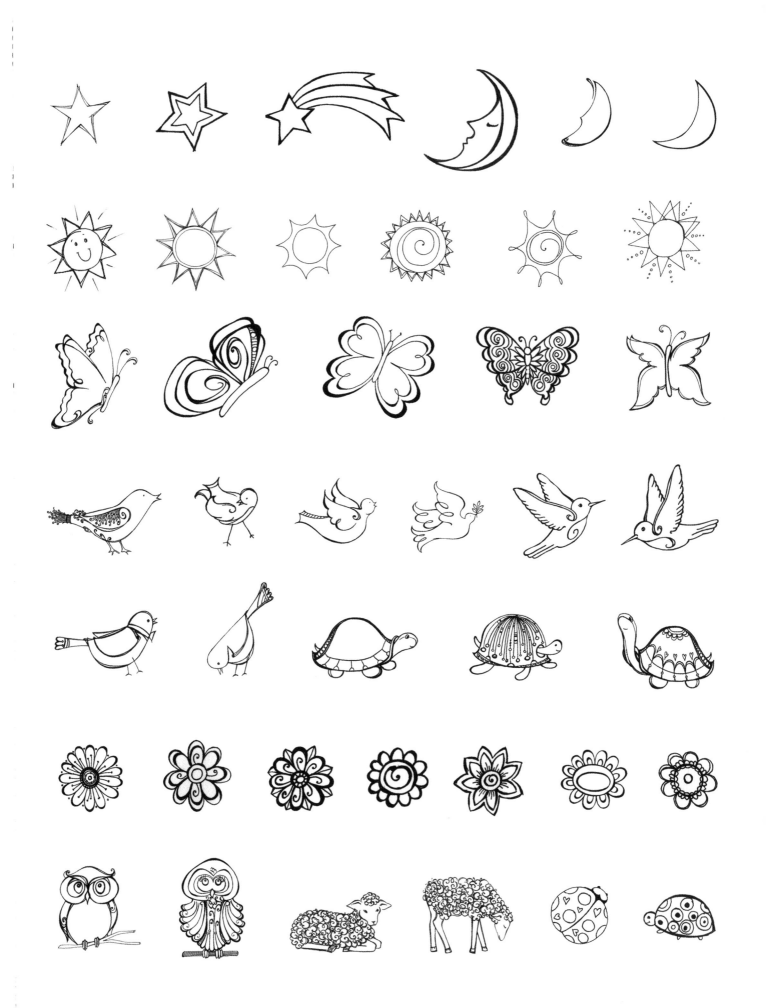

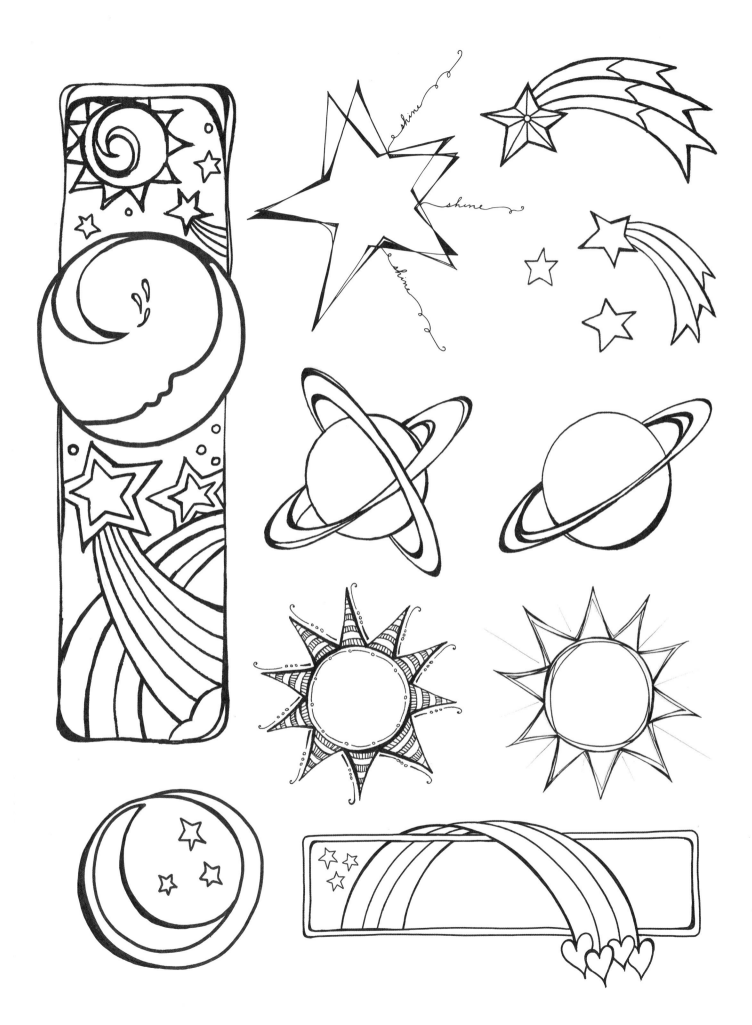

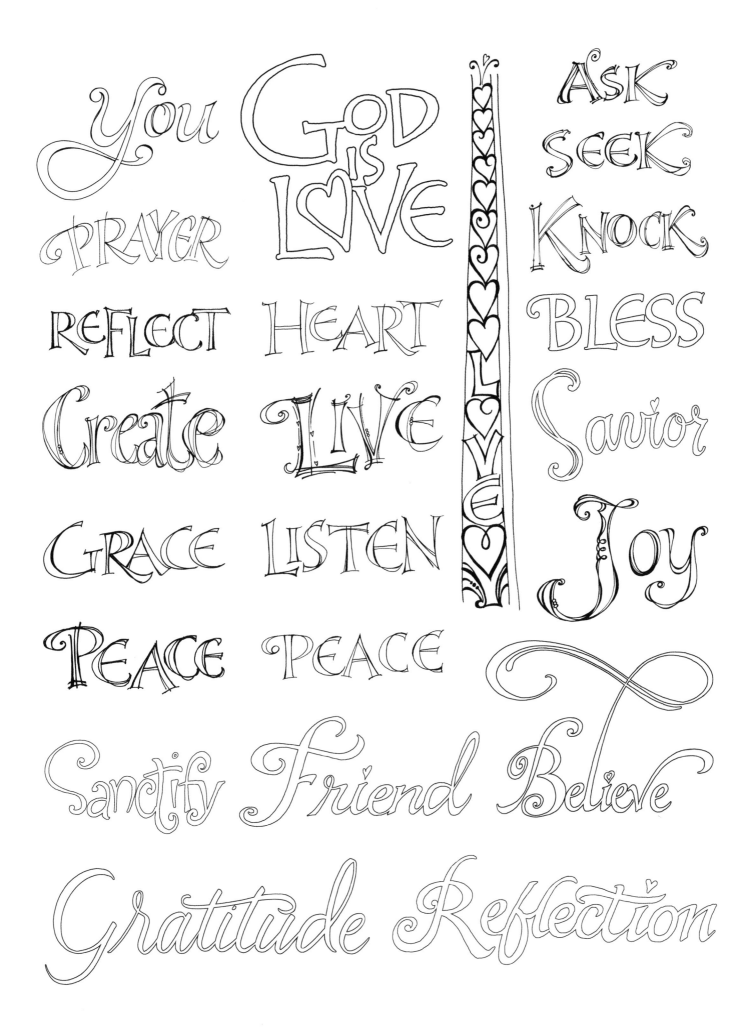

You God is Love Ask Seek Knock

Prayer Reflect Heart Bless

Create Live Savior

Grace Listen Joy

Peace Peace

Sanctify Friend Believe

Gratitude Reflection

illuminate

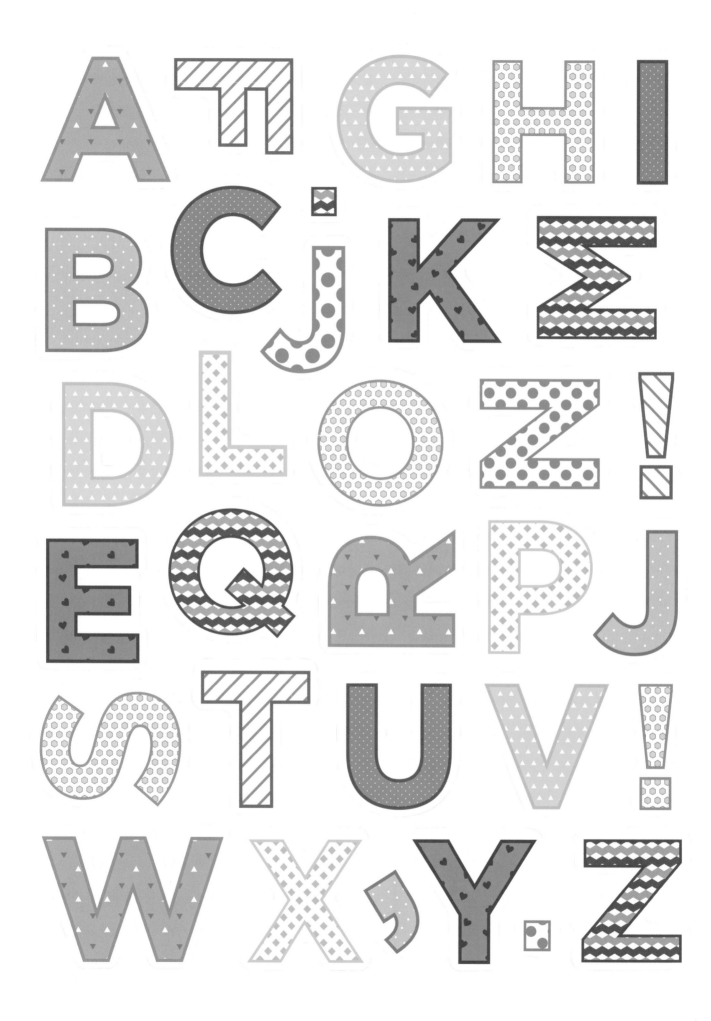

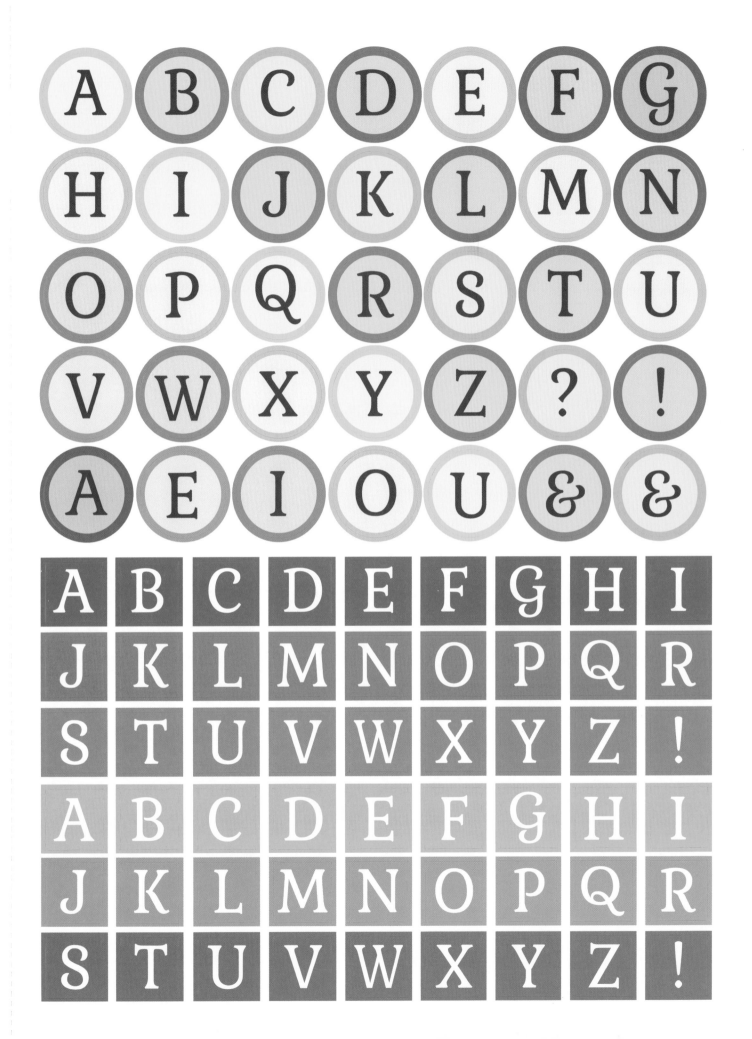

TAKE
NOTE

FAVORITE
VERSE

DEVOTION

SERMON
BY

REMEMBER
THIS

PRAY

AMEN

PRAY

TAKE
NOTE

DEVOTION

KEY
TAKEAWAY

FAVORITE
VERSE

GENESIS	EXODUS	LEVITICUS	NUMBERS	DEUTERONOMY	JOSHUA
JUDGES	RUTH	1 SAMUEL	2 SAMUEL	1 KINGS	2 KINGS
1 CHRONICLES	2 CHRONICLES	EZRA	NEHEMIAH	ESTHER	JOB
PSALMS	PROVERBS	ECCLESIASTES	SONG OF SOLOMON	ISAIAH	JEREMIAH
LAMENTATIONS	EZEKIEL	DANIEL	HOSEA	JOEL	AMOS
OBADIAH	JONAH	MICAH	NAHUM	HABAKKUK	ZEPHANIAH

THY WORD
IS A LAMP
UNTO MY FEET
AND A
LIGHT
UNTO MY PATH
PSALM 119:105

GIVE Thanks TO THE Lord FOR HE IS GOOD
PSALM 107:1

TAKE delight IN THE LORD AND HE SHALL GIVE YOU THE DESIRES OF YOUR HEART
PSALM 37:4

AS FOR ME AND MY HOUSE WE WILL SERVE THE LORD
JOSHUA 24:15

BE STILL AND KNOW THAT I AM GOD
PSALM 46:10

THIS IS THE DAY THE LORD HAS MADE LET US REJOICE AND BE GLAD IN IT

PSALM 118:24

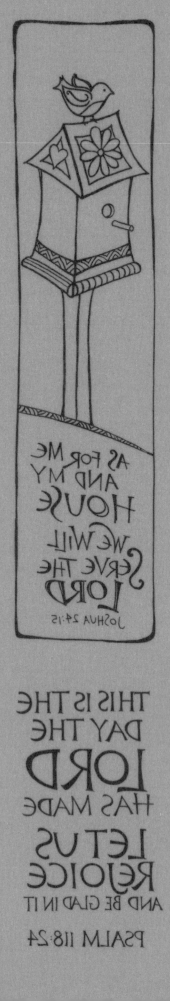

AS FOR ME AND MY HOUSE WE WILL SERVE THE LORD
JOSHUA 24:15

THIS IS THE DAY THE LORD HAS MADE LET US REJOICE AND BE GLAD IN IT
PSALM 118:24

GIVE thanks TO THE Lord FOR HE IS GOOD
PSALM 107:1

TAKE delight IN THE LORD AND HE SHALL GIVE YOU THE DESIRES OF YOUR HEART
PSALM 37:4

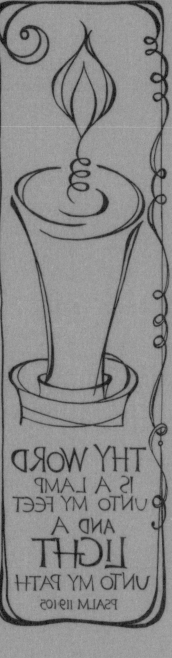

THY WORD IS A LAMP UNTO MY FEET AND A LIGHT UNTO MY PATH
PSALM 119:105

BE STILL AND KNOW THAT I AM GOD
PSALM 46:10

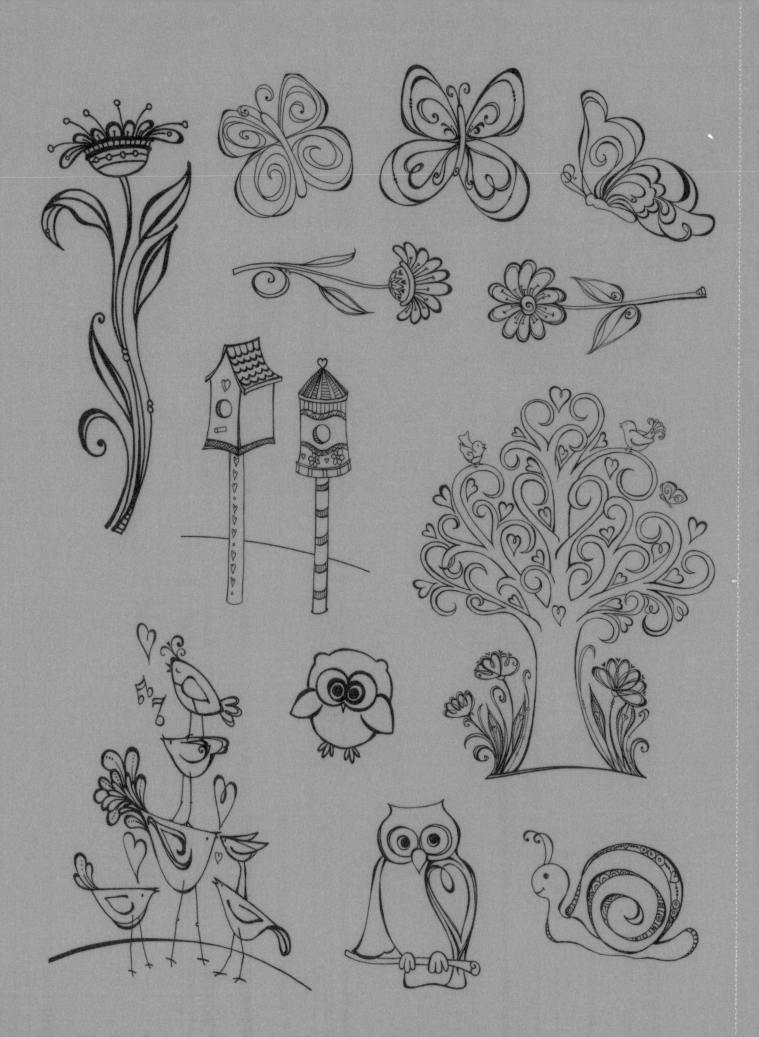

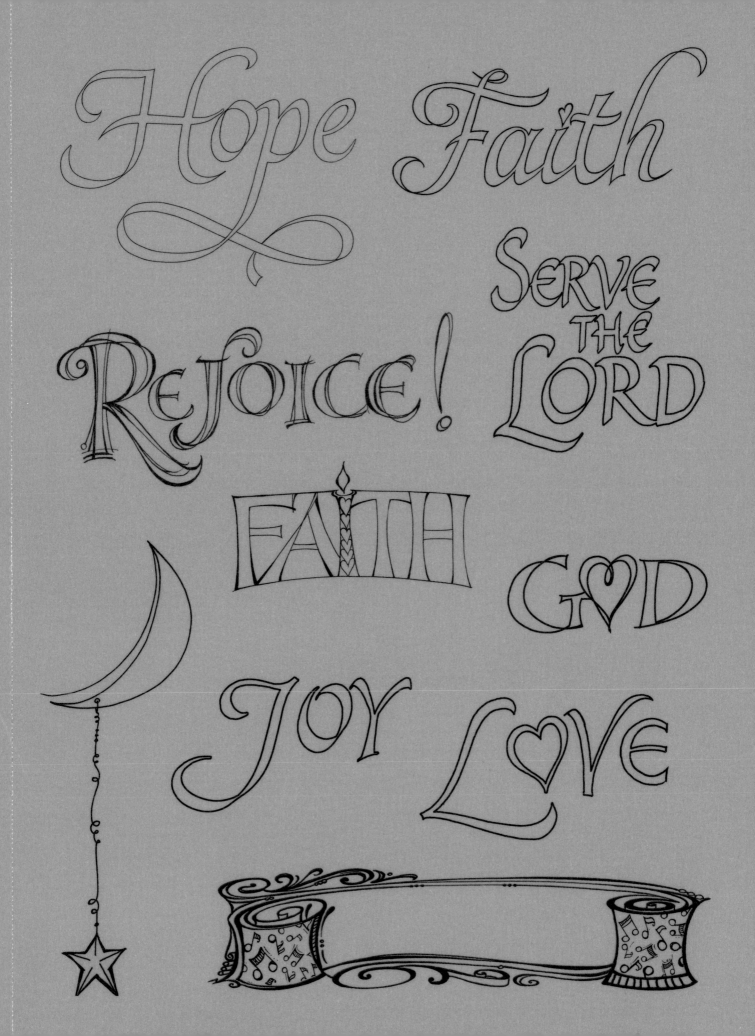